IMAGES
of America

RICHMOND

IMAGES
of America

RICHMOND

Donald Bastin

ARCADIA

Published by Arcadia Publishing,
an imprint of Tempus Publishing, Inc.
Charleston SC, Chicago, Portsmouth NH,
San Francisco

Printed in Great Britain.

Library of Congress Catalog Card Number: 2003110509

For all general information contact Arcadia Publishing at:
Telephone 843-853-2070
Fax 843-853-0044
E-Mail sales@arcadiapublishing.com
For customer service and orders:
Toll-Free 1-888-313-2665

Visit us on the internet at http://www.arcadiapublishing.com

CONTENTS

ACKNOWLEDGMENTS

Richmond, California, is my home town. My brothers and I were born here, as were my parents and many cousins, aunts, and uncles. Both sets of grandparents settled in the Richmond area during or before World War I. Our family memories are intertwined with the collective memory that is called the "History of Richmond." With others we share the joy of recognizing familiar places, where important things, little or large, took place. We share too the sadness of knowing that some places are gone forever, though the images remain. It is perhaps with the realization of what is gone that interest in one's home town grows; for it is only in my middle years that I have learned much about the town in which I grew up. I am still learning.

In this process of learning I am indebted to the Richmond Museum of History and to the museum's governing board, which has freely made available its fine collection of photographs. Virtually all the photographs used in this book (unless otherwise noted) are from this collection. The museum's roots are also entwined with the history of the city. The museum itself is located in the old city library, at the corner of Fourth Street and Nevin Avenue. Built in 1910 with a Carnegie grant secured by the local Women's Improvement Club, the old structure served as a library until 1950, when the new library at the new civic center opened. It was Richmond's civic-minded women who again came to the rescue of the old building and at the same time created a home for the City's museum. I have served only a short time as the museum's director, but in that short time I have come to appreciate the complexity of the town's past and the difficulty in portraying that past.

Perhaps the most difficult task was simply winnowing the overwhelming number of excellent images to the relatively few for which we had room. In this task I would like to thank the Museum Association president, Lois Boyle, particularly for her ardent support of this project. Also, thanks go to two of our long-term volunteers and founders, Mary Tom Coe and Helen Pence. Their knowledge of local events proved invaluable. Thanks too to my wife Clementina, who was unfailingly helpful and supportive, and who managed to keep other demands and people at bay while I was at work.

For information regarding the African-American experience in Richmond, I have relied heavily on the excellent and scholarly work by Shirley Ann Wilson Moore, *To Place Our Deeds*.

A special thanks goes to all those who have made donations, whether artifacts, documents, photos, time, or money, to our museum. Without this support, the story of Richmond's history could not be told.

INTRODUCTION

Where does the history of a place begin? For thousands of years the area along the San Francisco Bay which was to become the city of Richmond had been the home of a group of Indians called the Huchiun. The Huchiun were actually part of a larger group now referred to as the Ohlone, and this larger group occupied the area roughly between what are now the cities of Crockett and San Jose. The coming of the Spanish to the Bay Area in 1775 quickly brought this period of relative ease and innocence to an end. By the time Mexico assumed control of Alta California in 1821, after gaining independence from Spain, there were few local natives who could remember the old ways, and the Huchiun had largely died out or had been absorbed into neighboring tribes. Though they left stone tools and large mounds of shells and other cast-off bits of their lives, much has been lost or paved over, leaving archaeologists and ethnologists to puzzle over what remains. In contrast, the names of the early Californios, the Spaniards who had suddenly become Mexicans, are still very much with us, and color the historical landscape not only of Richmond, but the entire Bay Area.

Though the period of Mexican rule lasted but a short time—about 27 years—the local Californio land-owners continued to exert a strong influence on developments until the 20th century. In 1823 Francisco Castro was granted use of the land known as Rancho San Pablo, which covered an area roughly from Pinole to Oakland. Within this grant the town of Richmond was to form. But as late as 1894 county maps showed no town of Richmond or of San Pablo—just the large Rancho, bounded by Rancho El Pinole and Rancho El Sobrante. By the time that Richmond incorporated in 1905 the old Californio names had stuck, and became a permanent part of Richmond's legacy.

Other names have become part of Richmond's past, associated with a place or posted on a street sign. Names such as Macdonald, Barrett, Tewksbury, Nicholl, Parr, and Kaiser are old friends to the resident of Richmond, though little may be known of the actual bearer of the name. In large part the founding fathers were men of business and speculators, opportunists who saw a bright future for the city and for themselves. Their vision shaped the course of Richmond's history, a history dominated by the city's long waterfront and access to rail transportation. But perhaps no man's vision was as transforming as that of Henry J. Kaiser. It was Kaiser who made Richmond into one of the ship-building dynamos of the country during the Second World War, and thereby changed the city forever. In many ways the city is still trying to adjust to the terrible wrenching that it endured during that time.

Richmond has always been a town of big dreams, dreams that always seemed to be just out of reach. Blessed with a long waterfront, it hoped to rival the ports of San Francisco and Oakland. This never seemed to quite happen. The waterfront remains, and it is to that waterfront that the city has returned its gaze, partly for reasons of good business, but also because it is a beautiful shoreline and increasingly valuable for the enjoyment of its citizens and visitors. In Richmond's beginnings, it seems, are the seeds of its future.

One

RANCHOS TO RANCHES
RICHMOND IN THE LATE 1900s

In 1823, Francisco Castro and his wife Maria Gabriela Berryessa became the first European settlers in the area later to become Contra Costa County. Their 18,000-acre tract was known as the Rancho San Pablo, and encompassed all the land now within the city boundaries of San Pablo, Richmond, El Cerrito, and later, El Sobrante. On this land were raised cattle, horses, and sheep, as well as the usual farm crops. The family thrived and grew—11 children eventually being born to Francisco and Gabriela. For a time all seemed well, but under the surface were buried the seeds of discontent.

From the beginning problems arose concerning ownership of the land. While the Castros were granted use of the land in 1823, it was not until 1834 that formal title was granted by the Mexican government, and, by that time, Francisco was dead. His will left one-half of the entire estate to Gabriela, and the rest to the eleven children. Three of the daughters died before their mother, leaving their holdings to her, thereby increasing her interest to well over 50 percent of the Rancho. When Gabriela died, she left everything to her daughter Martina, causing dissension in the family and setting off a land dispute that would last for the next forty years. Aside from the family, many settlers and squatters had laid claim to portions of the Rancho, and they too joined in the legal fray. It was not until 1894 that these claims were sorted out and a final decree was made. Only then could real development take place, as speculators were reluctant to make investments in what might prove to be someone else's land. Until the beginning of the 20th century the Richmond area remained largely undeveloped. But it was not unoccupied. Men such as John Nicholl and Richard Stege lived on large ranches. And Capt. George Ellis operated the first cargo and ferry boats in the area. San Pablo was more settled during this time and the few Richmond residents shopped in its stores and sent their children to its schools. The colorful period of the Californios, however, was over.

The Castro family continued to play a large part in the history of the Richmond area. Don Victor, son of Francisco, built his two-story home alongside El Cerrito Creek in 1839 where the El Cerrito Plaza now stands. The Castro mansion was a landmark until 1956, when it was destroyed by fire. Victor has been described as tall, erect, and proud. Temperate in habits, it was said his word could always be trusted. He died in 1900, at age 80. His unmarked grave, and those of his wife and children, is located in the same area of the current plaza.

Another landmark of this period is the Alvarado Adobe in San Pablo. Juan Bautista Alvarado was California's first native-born governor (1836–1842), and he married Victor's sister Martina. In 1848, they moved into the adobe home originally built for the widow Gabriela, located on the corner of what is now San Pablo Avenue and Church Lane. The old adobe stood until 1954 when it was torn down to make way for an apartment house. The residents of San Pablo could never quite reconcile themselves to the loss of this relic of their past. In 1976 a replica was built, now serving as the city museum.

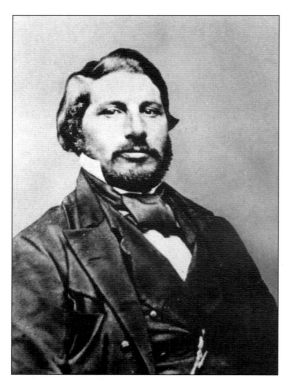

DON VICTOR CASTRO. Son of Francisco and Gabriela, his two-story home, built in 1839, stood where the El Cerrito Plaza is today. He, his wife, and four of his children are buried in the same area. At one time the Castro family owned over 19,000 acres, including all of present-day Richmond, El Cerrito, and El Sobrante. This vast estate was called Rancho San Pablo.

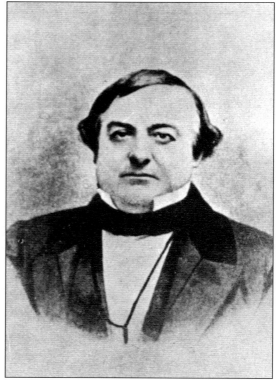

JUAN BAUTISTA ALVARADO. The first native-born governor of California, Alvarado served from 1836 to 1842. He married Victor's sister Martina Castro and moved to the family property in San Pablo in 1848. The couple had six children. Alvarado spent his time cultivating fruit trees, grapes, and roses. He died in 1882.

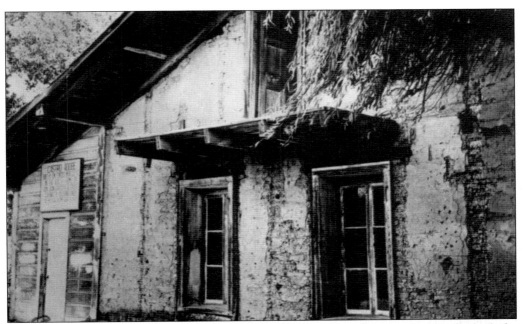

THE ALVARADO ADOBE. The home of Juan and Martina Alvarado, it was originally built for Francisco Castro's widow, Gabriela. The Alvarado Adobe, located on the corner of Church Lane and San Pablo Avenue, survived until 1954 when it was torn down to make way for an apartment building. A replica was built in 1976 which now serves as the museum for the city of San Pablo.

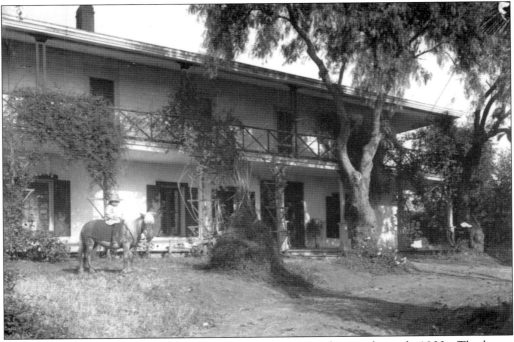

VICTOR CASTRO'S HOME, EL CERRITO. This picture was taken in the early 1900s. The home survived until 1956, when it was destroyed by fire.

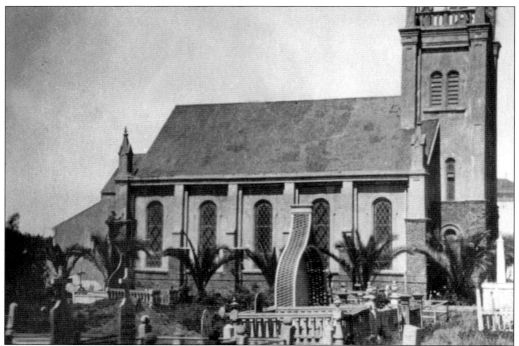

St. Paul's Church, San Pablo. This church was built in 1863 on land donated by Governor and Mrs. Alvarado. When it was torn down in the late 1930s (or early 1940s) the bones in the graveyard were unearthed and re-buried in nearby St. Joseph's cemetery.

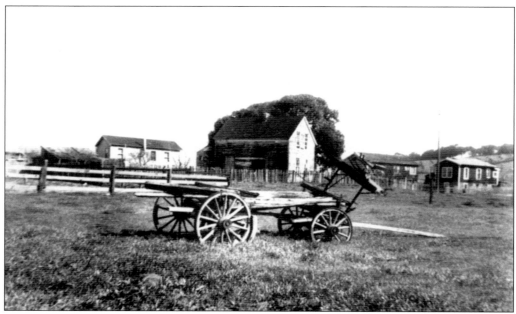

Tewksbury Home. This farmhouse, owned by the Tewksbury family, once stood at the corner of San Pablo Avenue and the Dam Road. The large pepper tree was a local landmark.

RUMRILL RANCH. Azro Rumrill was an early pioneer in the East Bay, and built this ranch on Road 20 in San Pablo. A promoter of education, he was a San Pablo school director. His daughter married Walter T. Helms, Richmond's first superintendent of schools.

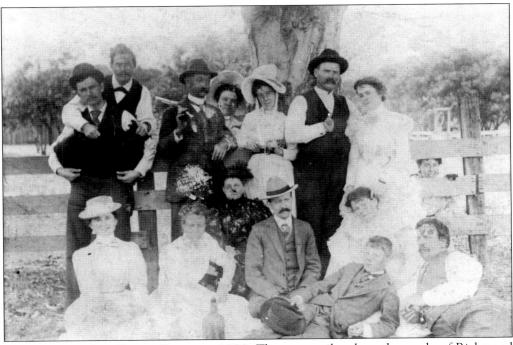

PICNIC ALONG SAN PABLO CREEK, C. 1898. The green miles along the creeks of Richmond and San Pablo have long attracted people seeking relaxation and shade. This playful group seems a bit overdressed for a casual summer outing.

JOHN NICHOLL RANCH, LATE 1800S. John Nicholl was one of Richmond's early land developers. His ranch was located along Macdonald Avenue, above Twenty-third Street. Present-day Nicholl Park was created out of a portion of this property when the ranch was sold.

WOMEN'S CHRISTIAN TEMPERANCE UNION PICNIC, NICHOLL RANCH. Women's groups have long been important in Richmond's development. The WCTU, along with other anti-alcohol groups, was instrumental in the passage of the Prohibition Act in 1918, leading to the demise of Richmond's winery at Winehaven.

14

GANDOLA FARM. The Gandolas were one of Richmond's early immigrants from Italy. Their dairy farm was located near present-day Alvarado Park.

ELLIS LANDING. Located at the end of Tenth Street (now Harbour Way), Ellis Landing was Richmond's first water-borne freight and passenger terminal. It was in operation from 1859 until the coming of the Santa Fe Railroad.

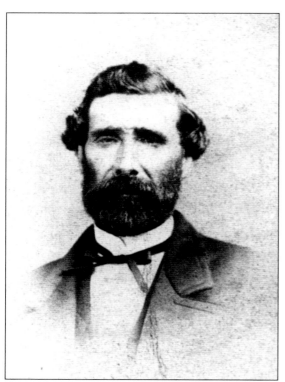

CAPT. GEORGE ELLIS. Captain Ellis ferried passengers and freight aboard his two small sailing vessels, *Sierra* and *Mystery*, until his death in the 1890s.

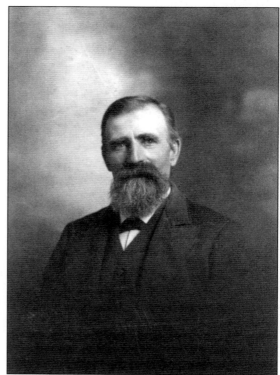

JOHN R. NYSTROM. As a boy, Mr. Nystrom worked for Captain Ellis, and eventually came to manage the business. Along with Harry Ells, he was one of Richmond's first school board members; and, like Ells, one of Richmond's schools was named after him.

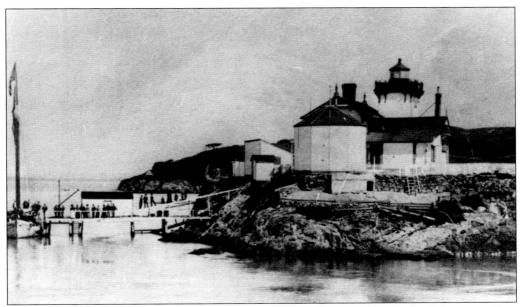

EAST BROTHER LIGHTHOUSE. Constructed in 1873, the East Brother Lighthouse in San Pablo Bay was a family-run operation. The Stenmark family lived here for over 20 years. Automated in 1968 the station is now on the National Register of Historic Places and is operated as a bed-and-breakfast.

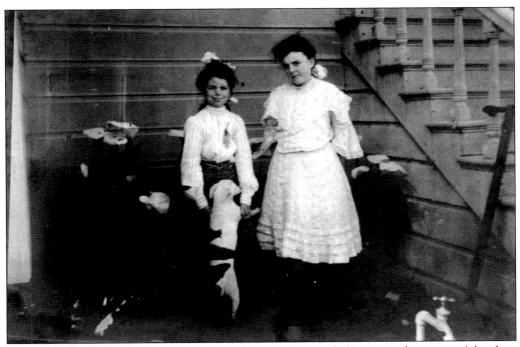

THE STENMARK GIRLS, C. 1900. Ruby and Annie Stenmark (Annie is the younger) by their home on East Brother Island. Annie was later courted by a young Standard Oil worker, who rowed to and from the island for fours years to press his suit. Their marriage lasted for over 50 years.

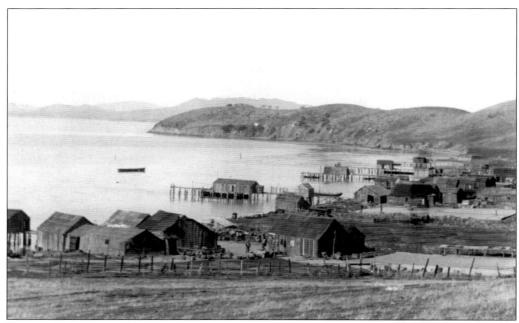

CHINESE SHRIMP CAMP, POINT MOLATE BEACH, EARLY 1900S. From 1865 to 1912, Chinese fishermen lived and worked at this beach near Point Molate. They netted bay shrimp, which they bagged and shipped to China, or sold locally.

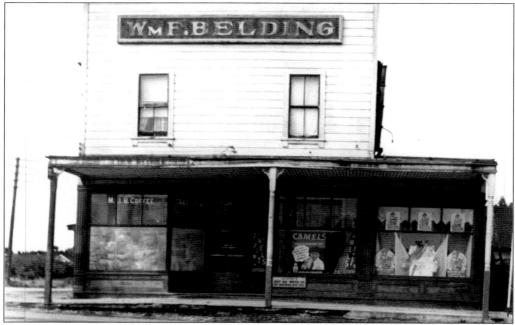

THE BELDING STORE. William Belding built his store in 1885 at the corner of Market and San Pablo Avenues, and served customers from Stege to Pinole. The building was still in operation in the 1930s when this picture was taken. Like the Alvarado Adobe, the Belding Store was torn down in 1954 to make way for a new apartment building.

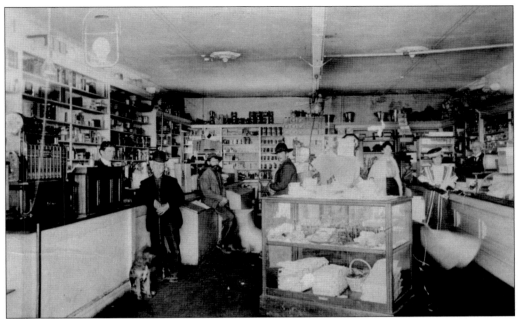

INSIDE THE BELDING STORE, 1901. Like most country stores, customers did not help themselves, but brought a list of items to be gathered together by the clerk. Staples were sold in bulk, usually from 100-pound sacks.

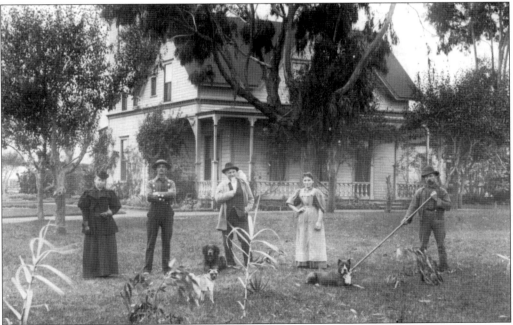

STEGE HOME AND FAMILY, 1880s. Richard Stege created a small town and a beautiful ranch when he married the widow Quilfeldt in 1870. Stege is the man with the bird on his shoulder, and his stepdaughter Edith is to his left. Long before Richmond became a town, Stege boasted a match factory, a chemical factory, a post office, and a railroad station.

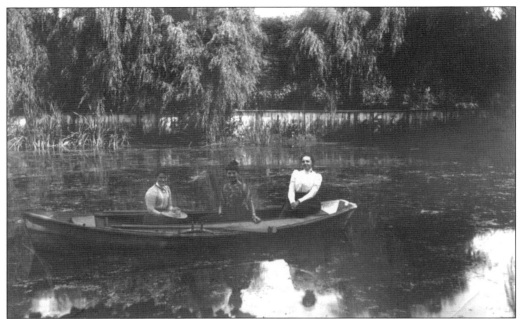

STEGE FROG POND, 1900. Stege raised and sold frogs to fancy restaurants in San Francisco. Here we see Edith (center) in a boat on the pond. The area near the pond and house is now encompassed by Richmond's Eastshore Park, at Forty-sixth and Potrero Avenues.

ALVARADO PARK. The area that was once known as Grand Canyon Park and later became known as Alvarado Park has always been a popular place to drive, hike, and have a picnic. It is now on the National Register of Historic Places.

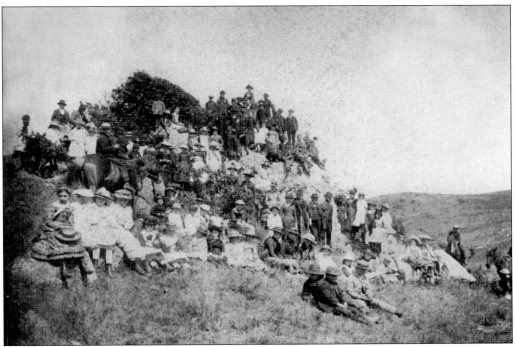

PICNIC IN THE PARK. This picture was taken in 1885, and shows students from the San Pablo School having a picnic in the area now known as Alvarado Park.

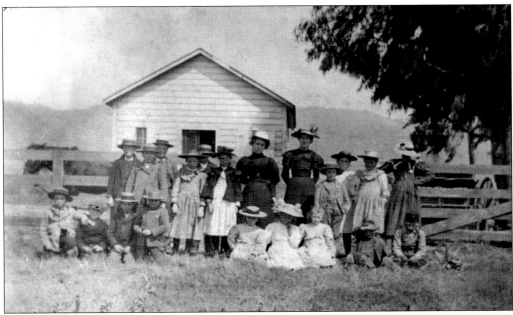

CASTRO/STEGE SCHOOL, C. 1870. Originally located behind Victor Castro's home in El Cerrito, this small, two-room structure was moved to the corner of Potrero and San Pablo Avenues in 1869. As this site was then within the town of Stege, the name was changed from Castro to Stege School. It served until 1912.

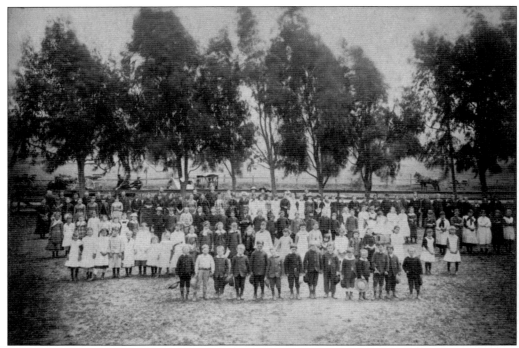

CHILDREN OF THE SAN PABLO SCHOOL, 1885. San Pablo Avenue is in the background, lined with eucalyptus trees and waiting carriages.

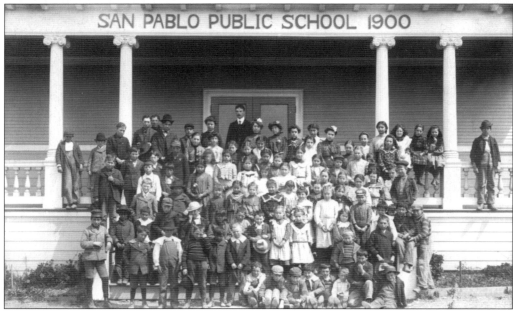

NEW SAN PABLO SCHOOL, C. 1901. As of this date, the San Pablo School District still served the needs of the students in the Richmond area. This school was located on Market Street in San Pablo. The newly hired Walter T. Helms is standing at the top of the steps.

SANTA FE SURVEY CREW, 1898. Surveyor Cliff Howard leads his crew in a survey of the prospective road bed and tunnel for the Santa Fe Railroad, which would be completed two years later.

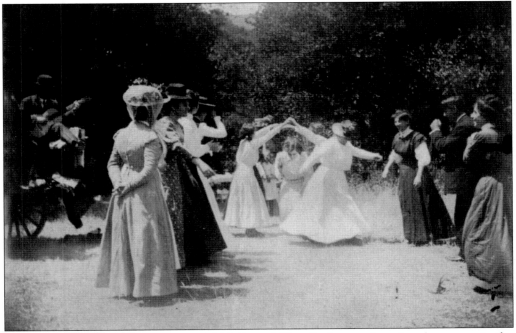

PICNIC IN LAUREL GLEN PARK, C. 1900. Laurel Glen Park was a favorite place to go in the early days of Richmond, either by horse-drawn wagon or train. It was located in the area now covered by the San Pablo Reservoir.

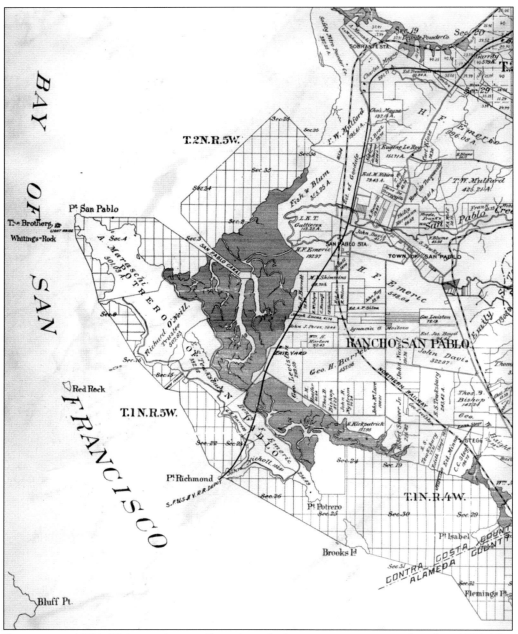

RICHMOND, 1894. This map is a small portion of a larger county map, produced in 1894. The coming years would radically alter the shoreline of early Richmond. Notice that the area between Point Richmond and the flatlands is a marsh, quite navigable at high tide.

Two

OIL AND WATER
THE EARLY 1900S

With the question of land ownership resolved by the court decree of 1894, Richmond was free to grow. By the opening of the 20th century the two major industries that were to determine Richmond's future were already in place. On July 3, 1900, the first Santa Fe passenger train chugged into town. At about the same time representatives of the Standard Oil Company began scouting out the area near Point Richmond as a possible site for their refining operations. The Santa Fe Company had been encouraged to locate in Richmond by a man named Augustin Macdonald. Following an unsuccessful duck hunt near San Pablo Bay in 1895, Macdonald had climbed the Potrero Hills and, looking over the largely empty landscape that greeted his gaze, thought the view "magnificent," not alone for its beauty, but for its "commercial possibilities." Once he had convinced the Santa Fe directors of Richmond's possibilities as a terminal, Macdonald turned his attention to making money. By the late 1890s few knew of the coming of the railroad, including one of the largest landowners in the area, George Barrett, who owned 550 acres of farmland in the heart of what was to become the town of Richmond. Macdonald, who did not tell Barrett what he knew of the Santa Fe plans, bought the Barrett farm for far less than it would soon be worth. Dividing the land into 5000 lots, he quickly sold off his holdings at a handsome profit, retiring to Oakland to build a mansion.

Standard Oil began its operations in Richmond in 1901 (it was then known as Pacific Coast Oil). Attracted by the available land, and access to rail and water transportation, the refinery first began to produce oil on July 4, 1902. The operation grew steadily, eventually occupying an area of nearly 1,800 acres and becoming the largest employer in the city at the time.

The proximity of these major employers dictated that Point Richmond (in the early days know as Eastyard) would be the center of town, at least for awhile. It was there that the first hotel, fire station, and city hall were located (the first hotel, in fact, was the first city hall). But by the time that the city had incorporated in 1905 the center had already begun to shift to the flatlands to the east, where it remained. Richmond in fact grew rapidly during the first decade of the 20th century, expanding from about 2,000 inhabitants in 1905 to around 10,000 in 1912. Streetcar, telephone, fire, and police services were provided. A separate Richmond School District was formed in 1903, which Walter T. Helms, the father of the Richmond school system, led until his retirement in 1949. Many new schools were built in this early period, including Richmond's first high school. Everyone predicted a continuation of this rapid expansion. However, growth never achieved the wild predictions of the boosters of these early years, and during the second decade of the century Richmond settled into a comfortable pattern of slow growth which it would maintain till the outbreak of the Second World War.

POINT RICHMOND, 1900. Washington Avenue is between the houses. The Critchett Hotel is the second building from the left, and was the first hotel in town. The hotel also served as the town's city hall until 1909.

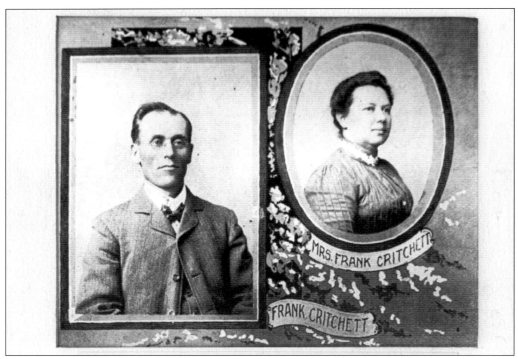

THE CRITCHETTS. Mr. and Mrs. Critchett owned and managed Richmond's first hotel. When the town was incorporated in 1905, Frank became one of the first five trustees of the city government.

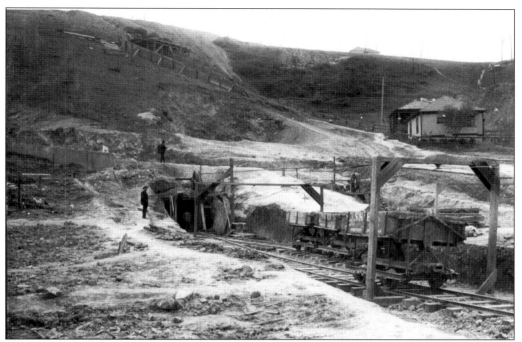

CONSTRUCTING THE SANTA FE RAILROAD TUNNEL, 1899 OR 1900. By May of 1900 the Santa Fe had completed all the major tasks needed to begin its operations in Richmond: the tracks were laid, the ferry slip was ready, and the tunnel completed.

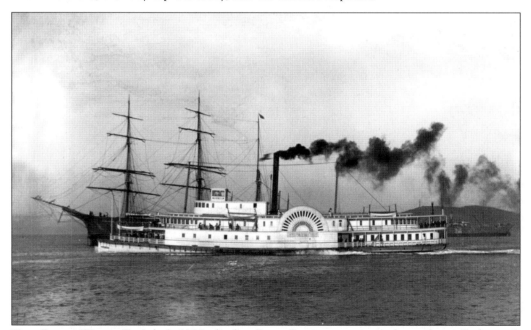

THE OCEAN WAVE. On July 3, 1900, the first Santa Fe passenger train chugged into Richmond. Ready to meet the passengers at the ferry terminal was the *Ocean Wave*, the first passenger ferry to operate between Richmond and San Francisco.

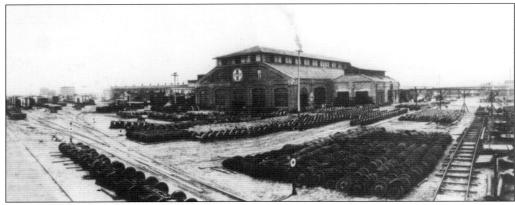

SANTA FE SHOPS, 1910. Santa Fe moved its railroad shops from Stockton to Richmond in January of 1901, and has been an important player in the town's history ever since. It is currently known as the Burlington Northern and Santa Fe Railway.

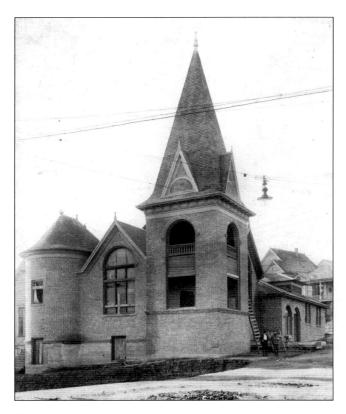

FIRST METHODIST CHURCH, POINT RICHMOND. The First Methodist Church of Richmond was officially organized in the home of Reverend Younglove in 1900. It claims the honor of Richmond's first recognized church. This building was completed in 1906.

OUR LADY OF MERCY CATHOLIC CHURCH. Organized shortly after the First Methodist Church, the Catholic Church is the second oldest church in Richmond. This lovely structure, erected in 1902, stands next to the First Methodist Church in Point Richmond.

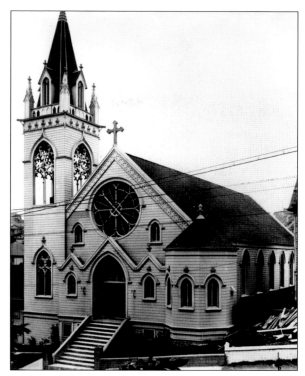

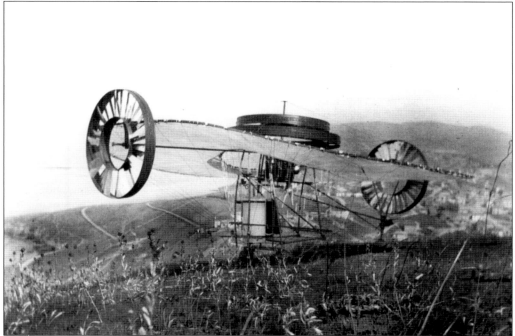

READY FOR TAKE-OFF. Late in the year of 1902, a man calling himself Professor Botts attempted to fly off the top of Nicholl Knob in this oddly designed aircraft. Shortly after this photo was taken, the machine was swept away by a gust of wind and smashed.

FUTURE SITE OF THE STANDARD OIL REFINERY. This picture, taken in 1901, looks north from Point Richmond. It shows that some filling-in which formed the foundation of the Standard Oil refinery had already begun.

STANDARD OIL OFFICE STAFF, 1900. The man in the derby hat, to the right, is Colonel Rheem, the Richmond plant's first superintendent. The lone woman is the secretary, Miss Macmillan. The man to the left is the Chinese cook, Jo Hi.

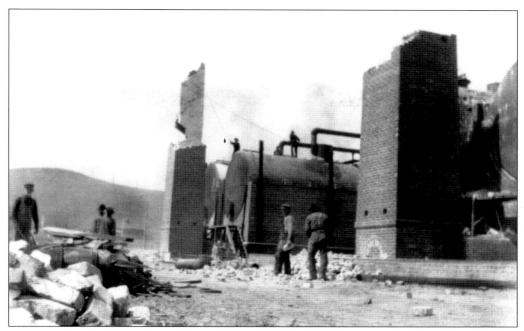

EFFECTS OF THE EARTHQUAKE OF 1906. This photo reveals damage to the first and second battery of stills, April 19, 1906.

INSTANT DEATH. After the earthquake of 1906, San Francisco authorities had ordered the National Guard to shoot all looters on sight. Not to be outdone, Richmond authorities ordered "instant death" to anyone engaged in criminal activities. It is not clear that anyone was actually shot.

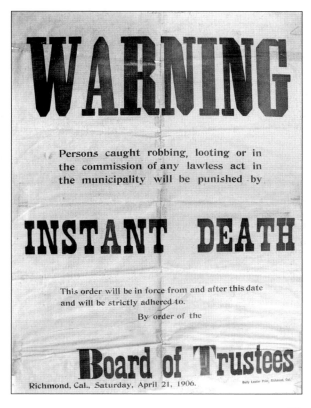

WARNING

Persons caught robbing, looting or in the commission of any lawless act in the municipality will be punished by

INSTANT DEATH

This order will be in force from and after this date and will be strictly adhered to.

By order of the

Board of Trustees

Richmond, Cal., Saturday, April 21, 1906.

31

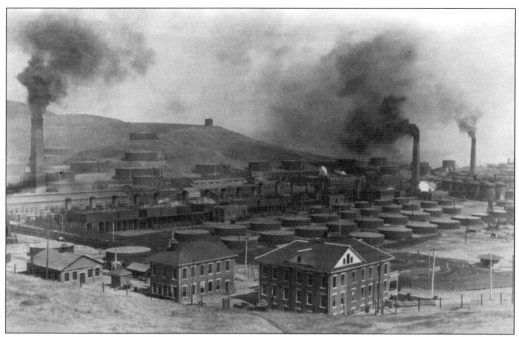

Standard Oil, 1907. Fully recovered from damage inflicted by the earthquake, the Standard Oil refinery was a booming operation by 1907, producing not only oil and gasoline, but processing whale oil as well.

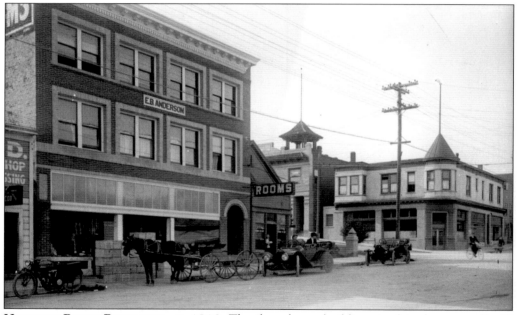

Historic Point Richmond, c. 1910. The three larger buildings in this photo are all still standing, and are included in the National Register. The building at the center right was Richmond's first bank. The Nicholl Building next to it served as Richmond's second city hall from 1909 to 1915.

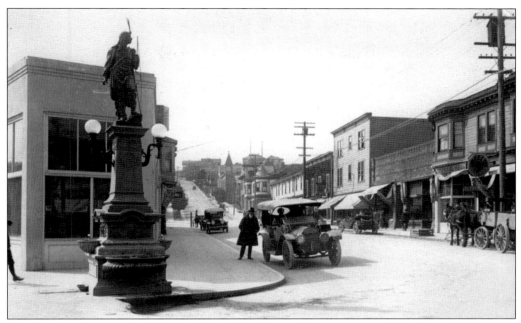

THE INDIAN STATUE. In 1909 the West Side Women's Improvement Club donated this statue and fountain to the City. It disappeared in the 1930s under mysterious circumstances. In 1984, the residents of the Point raised a new statue in its place.

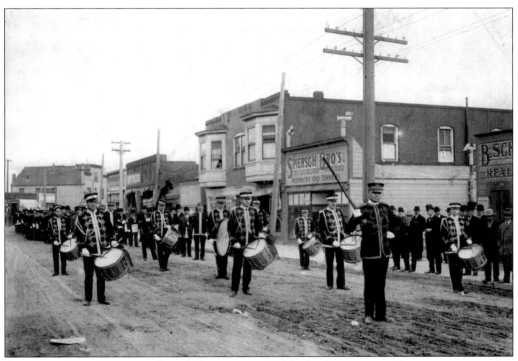

FOURTH OF JULY PARADE, POINT RICHMOND, 1910. At this time parades were very much a part of American life and no Independence Day could pass without one.

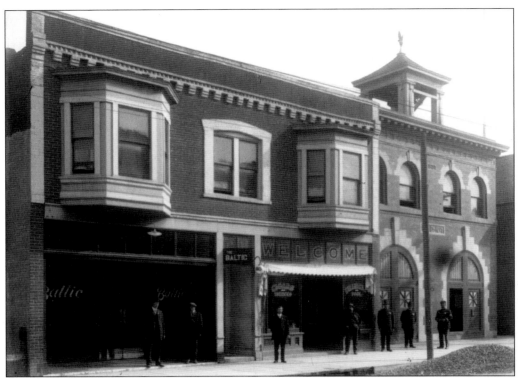

MORE HISTORIC POINT RICHMOND. The Baltic, a saloon, and the old brick Firehouse #1 still stand and are also part of Point Richmond's colorful historic district.

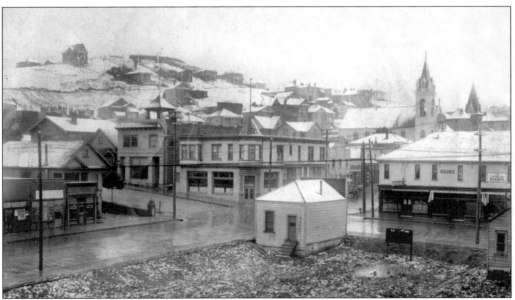

SNOW IN RICHMOND. The wonder of snow in Point Richmond was captured in this photo taken in the early part of 1913. In the center right can be seen the spires of the First Methodist and Our Lady of Mercy Churches.

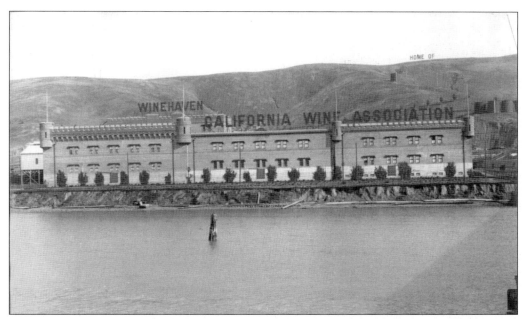

WINEHAVEN, C. 1907. The California Wine Association moved their operation from San Francisco to Point Molate following the earthquake of 1906. Until Prohibition, Winehaven boasted that it was the largest winery in the world. The building still stands and is on the National Register of Historic Places.

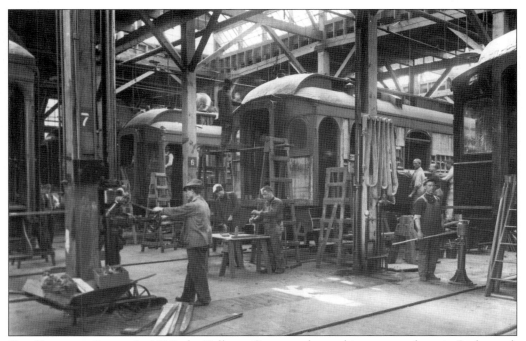

THE PULLMAN SHOPS. In 1910, the Pullman Company located its western shops in Richmond. Every two years the elegant sleeping cars were repaired and repainted. The original building is still standing along Carlson Boulevard.

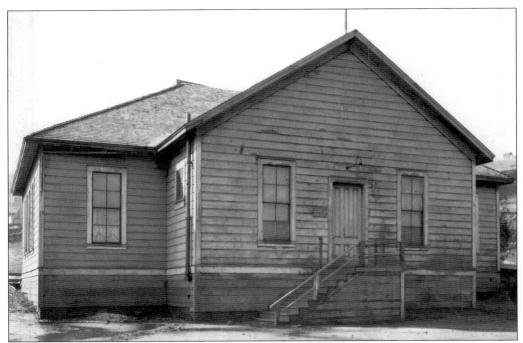

RICHMOND'S FIRST SCHOOL. This two-room building, erected in 1901 along Standard Avenue in Point Richmond, was the first school to be built in what was to become the City of Richmond.

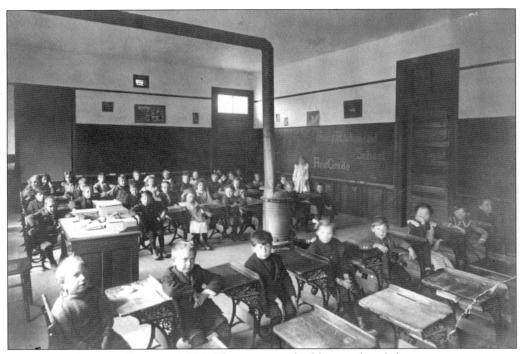

STANDARD AVENUE SCHOOL, 1906. This six-room building replaced the two-room structure in 1906. The heating system was common at the time.

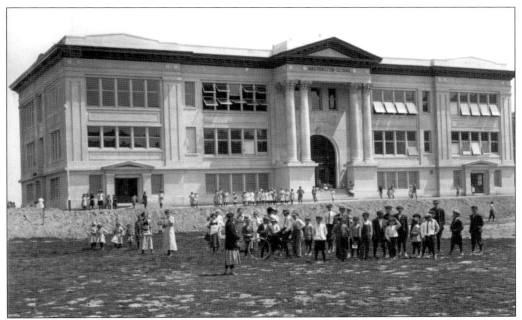

WASHINGTON SCHOOL, POINT RICHMOND. Built in 1912 to accommodate Richmond's rapidly expanding population, Washington School replaced the Standard Avenue School. It was in turn torn down and replaced in 1941.

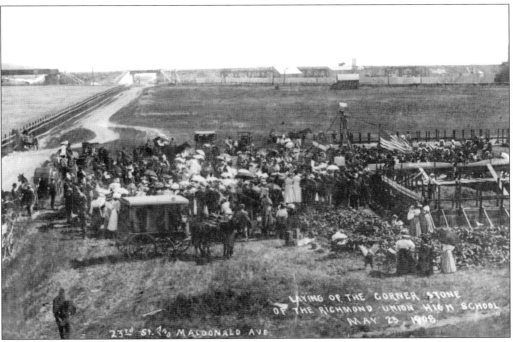

LAYING THE CORNERSTONE. Richmond's first high school was started on May 23, 1908. Located at the corner of Twenty-third and Bissell, this structure served as Richmond's only high school until 1928.

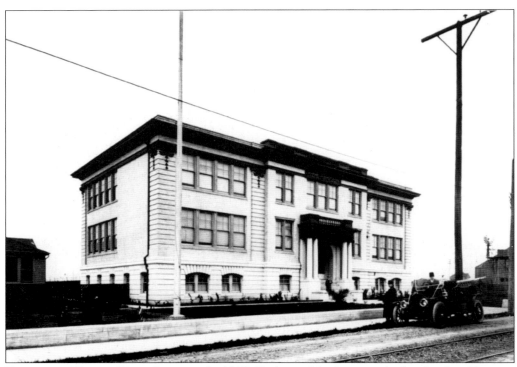

RICHMOND UNION HIGH SCHOOL. In 1928, Richmond built a new high school at Twenty-third and Tulare Streets. The old high school then became Longfellow Junior High.

THE PERES SCHOOL. The original Peres School was located at the corner of Fifth and Pennsylvania, built on land once owned by the Peres family. This building has since been replaced by a more modern structure.

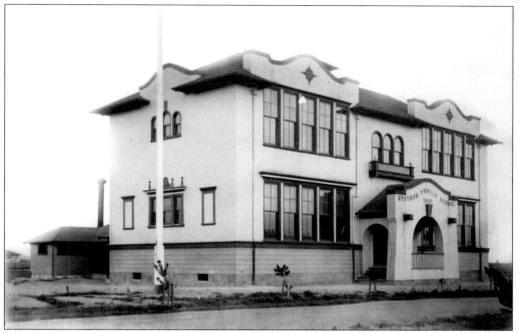

NYSTROM SCHOOL. John Nystrom, one of the members of Richmond's first school board, donated the land to build this school. It was opened in 1908. Though much altered over the years, the original structure still stands.

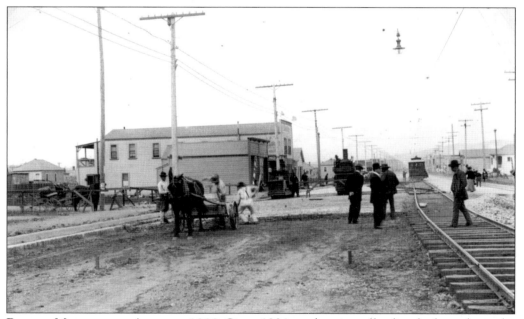

PAVING MACDONALD AVENUE, 1909. Since 1904 an electric trolley line had run down the center of Macdonald Avenue, at the time just a dirt road. The streets were so muddy that trolley passengers were sometimes reluctant to disembark at their destination, preferring a more distant, drier stop.

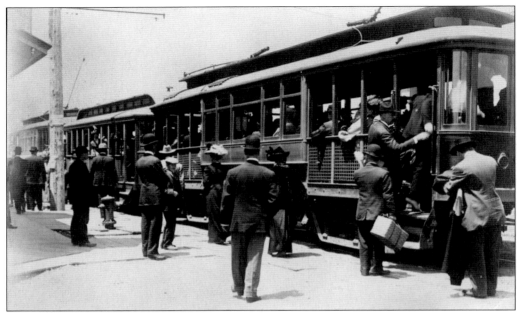

RUSH HOUR ALONG MACDONALD AVENUE, 1907. The East Shore and Suburban Railway was formed in 1904, and its tracks ran to the Alameda County line. Branch lines ran to San Pablo and to Grand Canyon (Alvarado) Park.

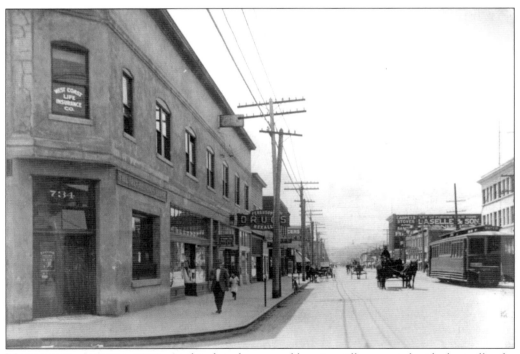

MACDONALD AVENUE, 1913. At this date, horses and buggies still competed with the trolley for space on the road. At the left is the old Mechanics Bank, which later relocated two blocks east, to Ninth and Macdonald. This newer building, designed as something of a Greek temple, still stands.

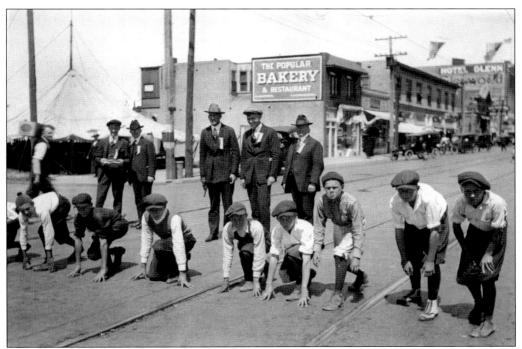

BOYS FOOT RACE. This undated photograph was taken at Fourth and Macdonald, probably some time before 1915.

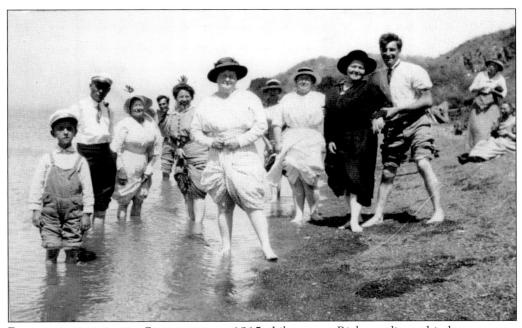

RELAXING ALONG THE SHORELINE, C. 1915. Like many Richmondites, this happy group enjoyed picnicking along the bay and wading in its shallow waters.

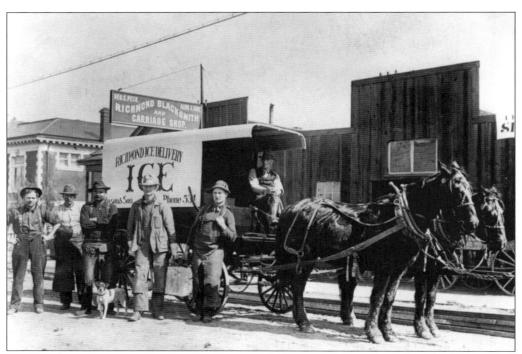

ICE WAGON. The ice company was an important business in early Richmond. Henry Mason and his father operated this business from the early 1900s to the mid 1930s. In the background can be seen Richmond's first library, at Fourth and Nevin, built in 1910.

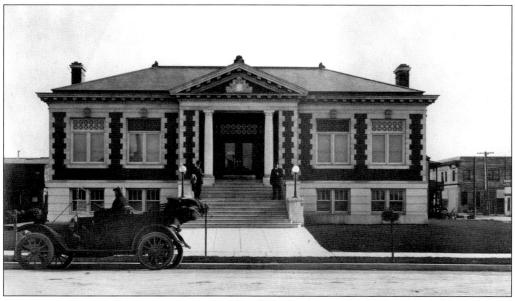

RICHMOND PUBLIC LIBRARY, C. 1912. Alice Whitbeck was the Richmond Public Library's first librarian when it opened its doors in 1910. The library was built with a $17,500 grant from the Andrew Carnegie Foundation, secured through the efforts of the Women's Improvement Club. Since the 1950s, the building has been home to the Richmond Museum of History.

Three

GROWING UP
THE TEENS AND EARLY 1920S

By 1915 the city of Richmond had passed through a period of rapid, youthful growth and entered into a period of early maturity, characterized by consolidation of the gains made in the earlier years and expansion beyond the borders of the Point. It was in 1915 that the tunnel through the Point Richmond hills was completed, allowing auto and truck traffic access to the developing waterfront. Construction began on the harbor itself, combining dredging and the construction of a seawall and a new wharf. The filling-in of the shallow marshland, which had already changed Point Richmond from an island to a peninsula, was extended to the shoreline. The shallow areas surrounding the growing city were either deepened to allow access by ocean-going ships, or filled to create more land. The transformation of Richmond's shoreline has been an important part of the town's development and it continues to the present day.

By 1915 it was obvious that the old City Hall, the John Nicholl building located in Point Richmond, was no longer adequate to the city's needs. Nicholl and another developer George Wall both offered to build new buildings at attractive prices. Thus began what came to be known as the "Battle of the City Halls." Wall's offer was initially accepted, and the city offices moved into the new Wall structure, located at Twentieth and Maine Streets, in June of 1915. Not one to be bested, Nicholl offered a larger, more expensive building free of charge. Placed before the voters, this offer was readily approved, and on January 1, 1917, the city departments packed up and moved once again. The Nicholl building, located at Twenty-sixth and Nevin, served Richmond until 1949, when the new City Hall was completed.

The City of Richmond saw another significant first in 1915. It was in March of that year, at the instigation of Capt. Raymond Clarke, that the Richmond–San Rafael Ferry & Transportation Company was formed, with the little steamer *Ellen* carrying the first passengers. Shortly thereafter, the *Ellen* was replaced by a new ferry built specifically for the job, the *Charles Van Damme*, named after the company's first president. The ferry company operated until 1956 when the new Richmond-San Rafael Bridge rendered its services unnecessary.

By 1915 developers had begun to look beyond Twenty-third Street, unofficially recognized as the town's eastern boundary. They laid out streets, lights, water, and sewer systems, but little else. At this time, developers did not build or sell houses, just lots. The lots, however, sold slowly, and the area between Twenty-third and the East Richmond Hills remained largely open for decades to come. In 1920 the city reached beyond this largely empty area and purchased the grandly named Grand Canyon Park and renamed it Alvarado Park, after the state's first native-born governor. The park (now on the Federal Register of Historic Sites) had always been popular, and was a favorite place to picnic, dance, or listen to the band on Sundays. But for both recreation and business needs, it was along Macdonald Avenue that Richmondites now spent much of their time. The center of town had definitely shifted to the east, and while for a time Ohio Avenue competed with Macdonald for importance, by the late teens Macdonald Avenue had become the place in which to do business and to have fun. It would not relinquish this position until well after the end of the Second World War.

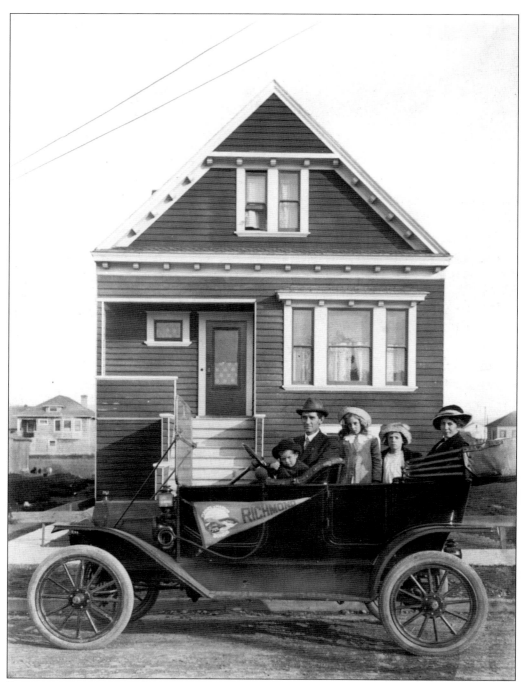

RICHMOND BOOSTERS. This is the Burns family, sitting in their Model T Ford, in front of their new Richmond home, located at 124 Tenth street. They are confidently boosting the sale of city bonds to cover the construction of the Richmond Tunnel, allowing road traffic to Ferry Point and the new wharf. The house still stands, though the entrance is obscured by a boxy addition.

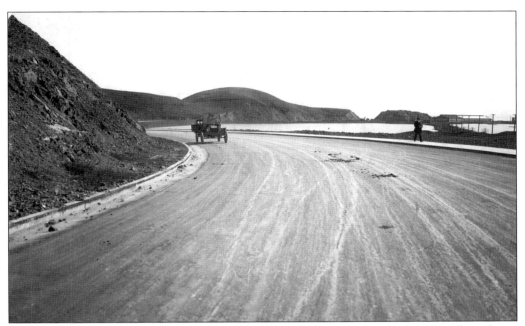

VIEW FROM THE RICHMOND TUNNEL. The tunnel was completed in 1915. This photo, probably taken in the same year, shows the Santa Fe Lagoon (where Miller-Knox Park is today) and the ferry terminal beyond.

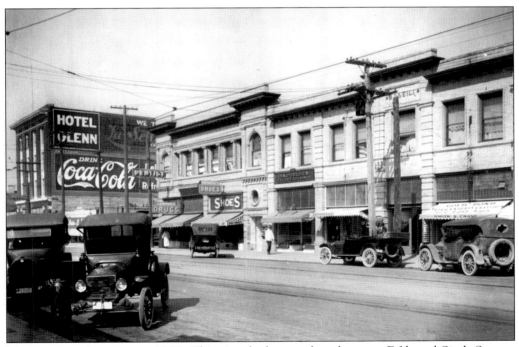

MACDONALD AVENUE, C. 1917. This view looks west from between Fifth and Sixth Streets, which was the center of the business district at this time. The Hotel Glenn, at the corner of Fifth and Macdonald, had been up for just a few years.

45

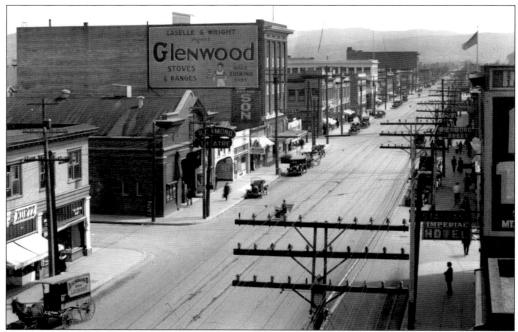

LOOKING EAST ALONG MACDONALD AVENUE. Taken about the same time as the previous picture, we see the development that has occurred since the town's founding in 1905. The Richmond Theater, opened in 1913, was one of the oldest theaters in town, and operated until the 1930s. The two-block area between Fourth and Sixth is now an open park.

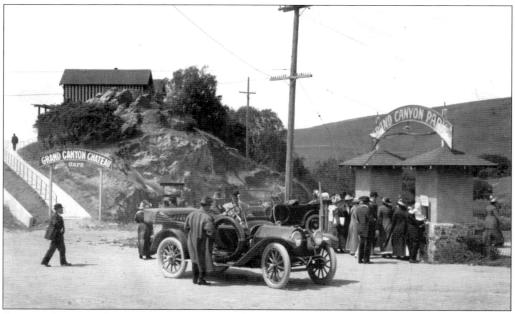

GRAND CANYON PARK, C. 1918. Later to become Alvarado Park, this spot has long been a favorite place to have a picnic or host family or company get-togethers. The building at the upper left is the "Chateau," at this time a high-class restaurant. It still stands and is now a private home.

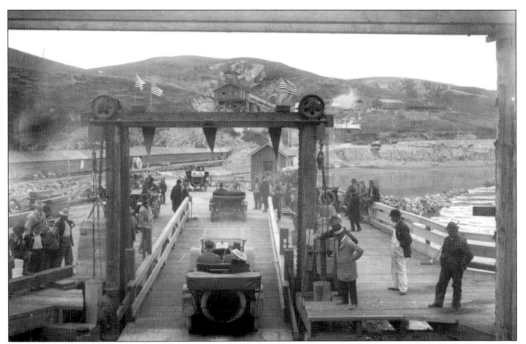

OPENING DAY, RICHMOND–SAN RAFAEL FERRY, MAY 1, 1915. Before this date, the only way to get to San Rafael from Richmond was to take two ferry rides: one from Oakland to San Francisco, and another from San Francisco to Sausalito—a seven-hour trip!

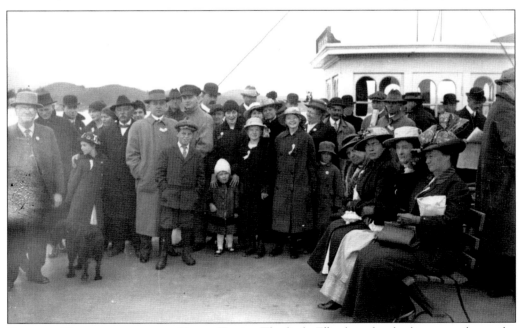

OPENING DAY, ON BOARD THE FERRY ELLEN. The little *Ellen* lasted only three months on the Richmond–San Rafael run. Declared unsafe, it was replaced by the much larger *Charles Van Damme*, built expressly for this service.

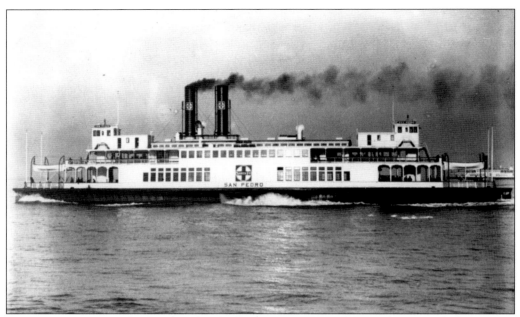

FERRY SAN PEDRO. This lovely side-wheeler was a Santa Fe boat and ran regularly between Richmond's Ferry Point and San Francisco.

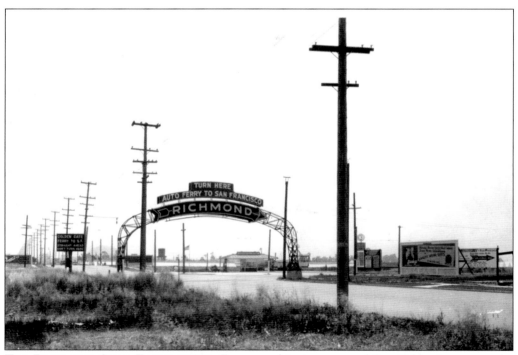

THE RICHMOND SIGN, EARLY 1920S. For years this sign spanned San Pablo Avenue at the intersection of Macdonald Avenue, pointing the way to downtown Richmond and the ferry terminals. The view is from about where the Safeway store is today.

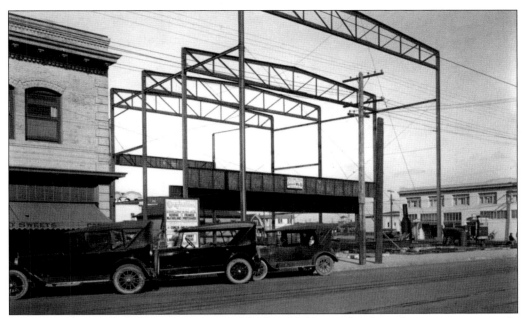

BUILDING THE T & D THEATRE, 1921. Macdonald Avenue has been home to many movie theatres. The T & D stood between Eighth and Ninth Streets. The building cost $40,000 to construct, on land purchased for $30,000. Two stories high, with stores on the ground floor, it was advertised as being "modern in every respect."

T & D THEATRE. The movie featured on the marquee is *Blood and Sand* starring Rudolph Valentino, which means this photograph was taken in 1922, the date that this silent film was released. In 1925 the name of the theatre changed to the *California*, and in 1930 it changed again to the *Fox California*. In the early 1950s the name changed once again to the *UA*, and a new Fox Theatre opened across the street, between Seventh and Eighth Streets.

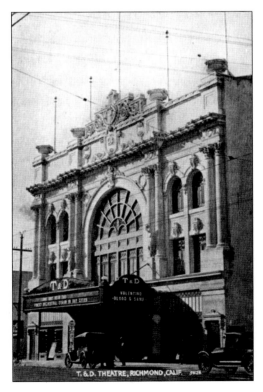

T. & D. THEATRE, RICHMOND, CALIF.

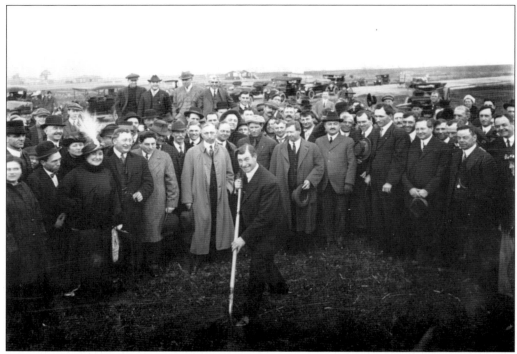

DEDICATION CEREMONY FOR NEW CITY HALL, 1915. Mayor Edward Garrard turns the first spade of earth in the building of the new city hall, funded by contractor George Wall.

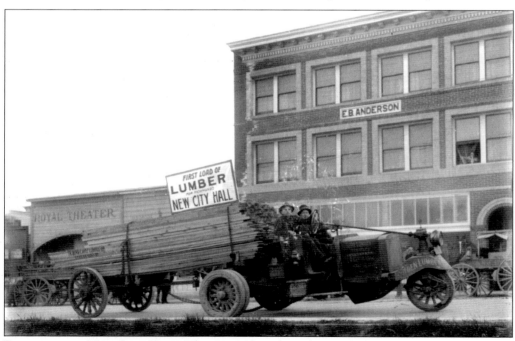

BUILDING THE NEW CITY HALL. This unusual truck, with a single front wheel and chain drive, is hauling lumber to the construction site of Richmond's new city hall.

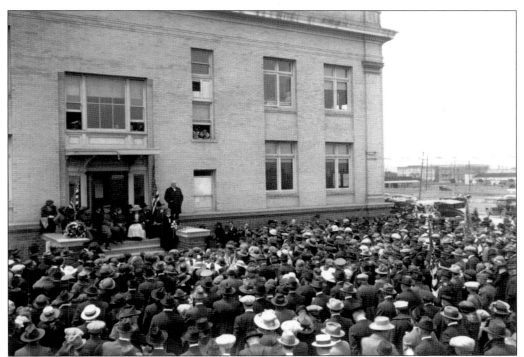

DEDICATION OF THE JOHN NICHOLL CITY HALL, 1916. The building built by George Wall, on Twentieth and Maine Streets, was only in use for a little over a year before the city offices moved into the Nicholl Building, which officially opened on January 1, 1917.

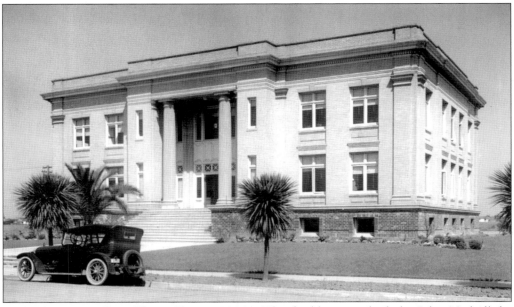

THE RICHMOND CITY HALL, EARLY 1920s. This building was built by John Nicholl for $25,000 and was given free of charge to the City of Richmond. The "Greek Temple" style of architecture was typical of its time.

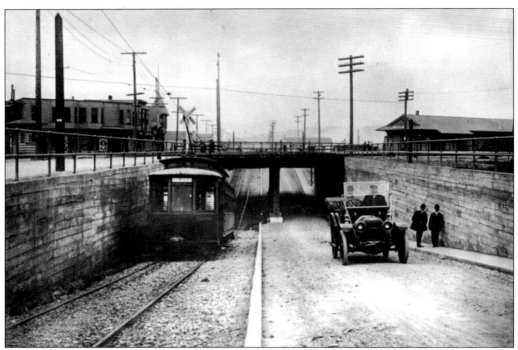

SOUTHERN PACIFIC UNDERPASS, MACDONALD AVENUE, 1911. At the upper right can be seen the Southern Pacific train station, at Sixteenth and Macdonald.

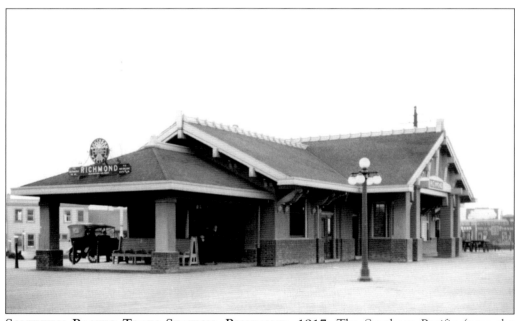

SOUTHERN PACIFIC TRAIN STATION, RICHMOND, 1917. The Southern Pacific (now the Union Pacific) has run trains through Richmond since 1878 and still maintains a small, open station (alongside the BART station), but this elegant old building is long gone.

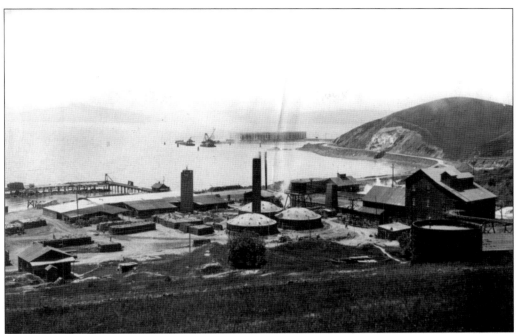

RICHMOND (FORMERLY LOS ANGELES) PRESSED BRICK COMPANY, C. 1915. Supplying bricks to Richmond and the entire Bay Area, this company operated in the area now known as Brickyard Cove. Terminal #1, near Ferry Point, is under construction in the distance.

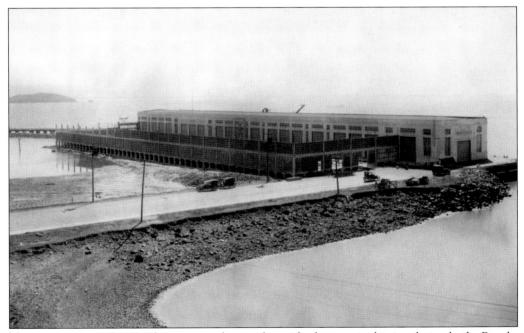

TERMINAL #1, C. 1919. The new warehouse alongside the terminal is just being built. Brooks Island is in the distance. The Victory Ship *Red Oak Victory*, owned by the Richmond Museum Association, is today moored alongside the old terminal.

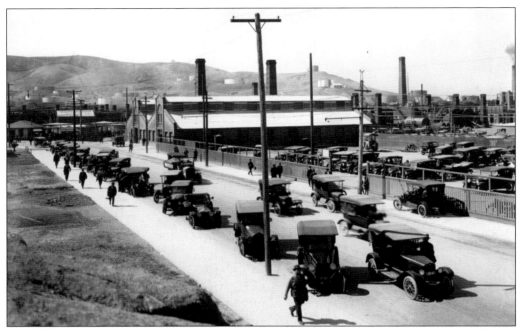

QUITTING TIME, C. 1918. The first still in the Standard Oil refinery became operational on July 2, 1902. From that date to the present, the oil company has been one of Richmond's major employers.

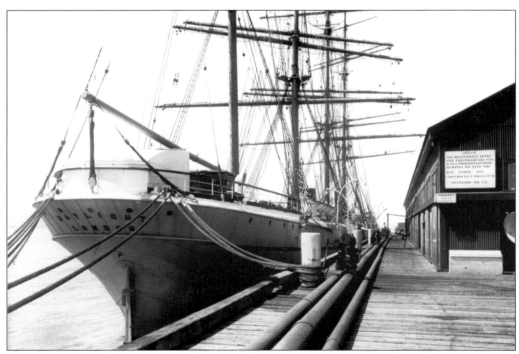

STANDARD OIL LONG WHARF, C. 1920. Sailing vessels were a common sight on the Richmond waterfront well into the 20th century.

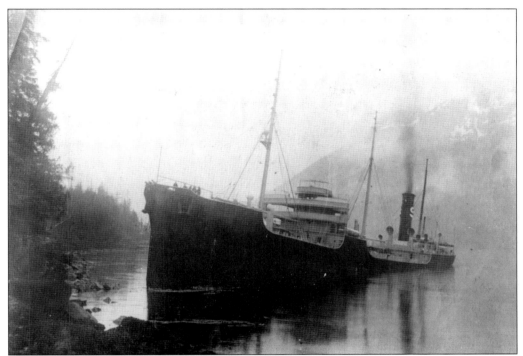

SS *RICHMOND*, AGROUND, 1921. The *Richmond* was a Standard Oil tanker, built in 1913. The vessel performed valuable duty during World War I, carrying oil to Great Britain. This photo shows her grounded in Port Allen, Alaska. She was successfully re-floated and gave many more years of service. A large model is on view at the Richmond Museum of History.

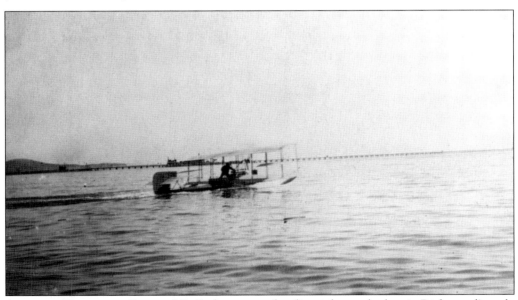

ANOTHER PROFESSOR BOTTS. J.R. Froberg was a familiar sight on the bay in Richmond's early days. Here he is in 1913 testing his hydroplane. A year later he crashed into the bay. Froberg was uninjured, but his plane was a total loss, and he quickly faded from the news.

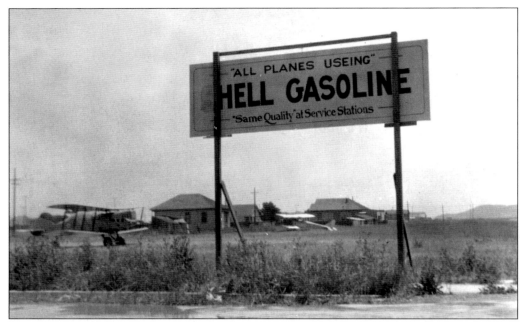

RICHMOND AIRPORT. Richmond once claimed its own little airfield, as this picture shows. It was located in an area near the bay called "clam flat," south of Cutting Boulevard at the end of Fourteenth Street (now Marina Way).

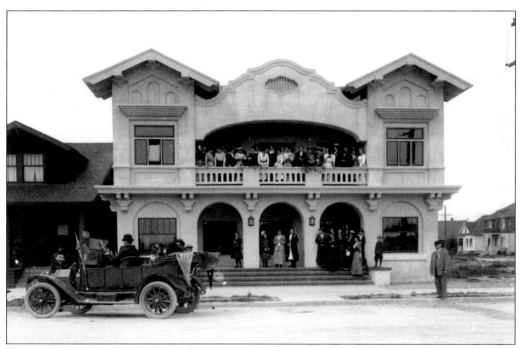

WOMEN'S IMPROVEMENT CLUB, TWELFTH AND NEVIN, 1916. Women were very important in the civic and cultural life of Richmond. Single-handedly, this group secured funding and land for the construction of the Richmond's first library in 1910.

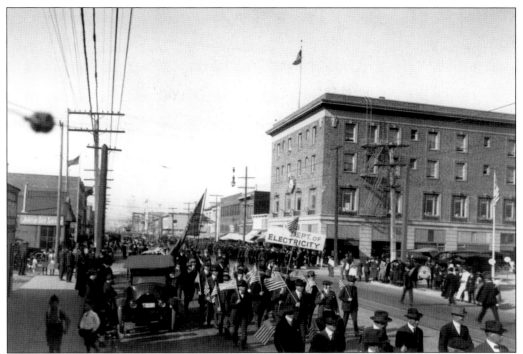

FOURTH OF JULY PARADE, 1919. This picture was taken along Macdonald, looking west. The large structure in the background is the Elks Building, which stood at the corner of Tenth and Macdonald and was a prominent landmark. Long since torn down, a community garden now covers the otherwise vacant lot.

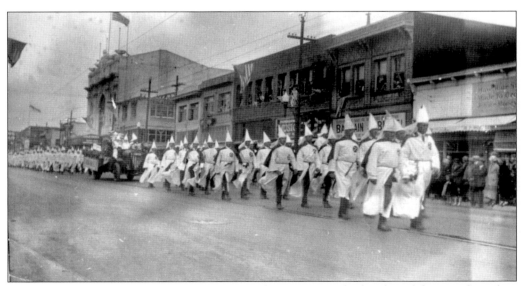

ANOTHER FOURTH OF JULY PARADE, 1924. The 1920s was the heyday of the Ku Klux Klan, and since 1917 its members openly participated in Richmond's celebrations. In addition to espousing the supremacy of native-born whites, they were against the increasing numbers of immigrants then flooding into this country from Southern Europe and Asia.

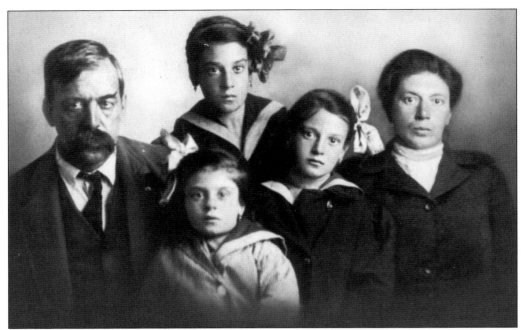

THE TRAVERSO FAMILY. Whether the Klan liked it or not, Richmond always had a diverse population. Before World War II Italians comprised the largest foreign-born element in Richmond's population. The Traversos have been a part of Richmond's history since the early 1920s.

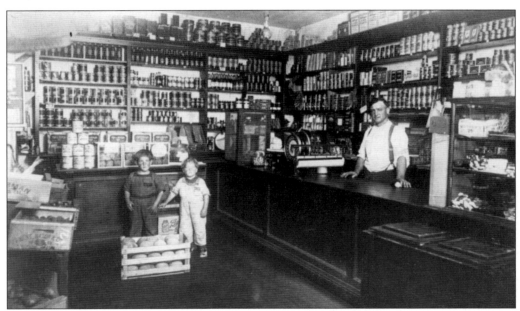

MENEGHELLI STORE, C. 1923. While they ran few large businesses (the Filice and Perelli cannery being an exception), Italian Americans ran many small, family operations in Richmond. Seen here is the senior Meneghelli and his sons Art and Joe in their grocery store which was located on Wall Avenue, between South Thirty-ninth and Fortieth Streets.

TORAYOSHI MAIDA. People of Japanese ancestry have also figured prominently in the development of Richmond. The Maida family settled here around 1920. Torayoshi ran a nursery.

KANE MAIDA, EARLY 1920S. The wife of Torayoshi stands in front of her home at 4855 Felton (later Wall) Avenue in Richmond.

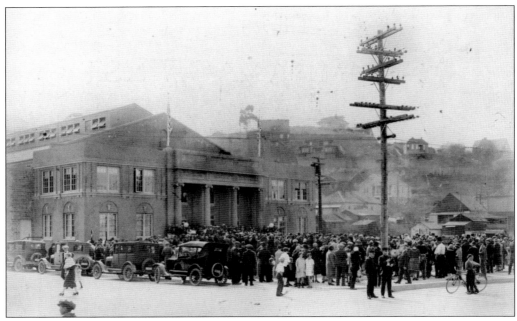

DEDICATION OF THE RICHMOND PLUNGE, 1925. Hoping to strike oil, Mr. Nicholl sunk a well on this land, only to hit water. He then generously donated the land and water, free of charge, to the city in order to build a municipal pool.

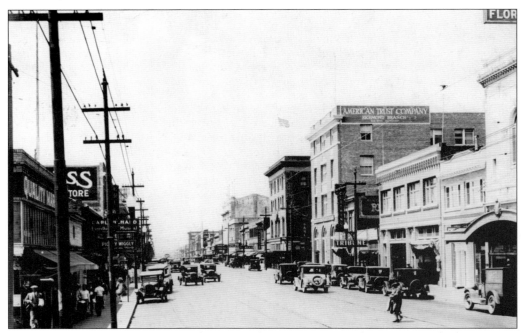

MACDONALD AVENUE, 1929. By the 1920s, this area, near Tenth Street, was the busiest part of town. The American Trust Building symbolized Richmond's beating financial heart. Down the street, at the California Theatre (previously the T & D), the featured movie was *Desert Nights* starring John Gilbert.

Four

SWIMMING AGAINST THE TIDE
THE LATE 1920S AND THE GREAT DEPRESSION

By 1925, much of the work on Richmond's outer harbor had been completed, and attention turned to developing what was termed the "inner harbor," the area around the old Ellis Landing, at the foot of Tenth Street (now Harbour Way). The man in charge of the work was Fred Parr, a waterfront developer and businessman. Under Parr's direction, Richmond's waterfront underwent further dramatic changes. The Santa Fe Channel was deepened and lengthened, reaching to Cutting Boulevard. The dredged material was used to create 210 acres of new land, upon which Parr built two shipping terminals. He also encouraged several companies to site their operations on this newly reclaimed land.

The first large operation to open its doors was the Filice and Perelli cannery, which began operations in 1930. The founders of the cannery were Italians, and it was no accident that they decided to locate their business in Richmond. At this time, Italians constituted the largest single group in Richmond, concentrated largely in the areas of North Richmond and Point Richmond. Hard-working and family-oriented, Italian workers had provided much of the labor for Richmond's early industries. Not surprisingly, most of the workers at the winery at Winehaven were Italian. It is also not surprising that the large work force at the Filice and Perelli cannery either had emigrated from Italy or were the descendants of Italian migrants. The nature of the labor meant that many women were able to work.

The largest and most important business to open up shop on the new land was the Ford Company. In the planning stages for years, Ford began to produce cars in Richmond in August of 1931. By this time the Great Depression was well under way. That Ford opened its Richmond facility at all was a great achievement, and fortunate for the city. Even more fortunate was the fact that all the major businesses operating in Richmond, and many of the smaller ones, continued to operate throughout the dismal years of the Depression. This is not to say that times were not hard, but the worst effects of the stagnant economy were certainly blunted by the ability of Richmond's businesses to keep their factories running and their employees working.

It was Parr, too, who induced Henry Kaiser to build a new shipyard in Richmond to construct cargo ships for embattled Britain. These efforts, added together, meant that when the time came for America to enter the war, Richmond would be ready to supply the ships needed by its own armed forces.

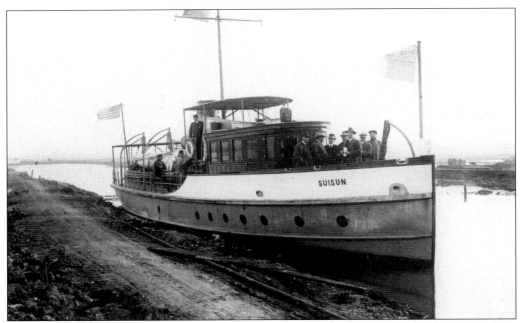

CHARTING THE INNER HARBOR. The late 1920s witnessed another surge of activity along Richmond's shoreline. Here, the launch *Suisun*, carrying engineers and city officials, surveys the marshy channels, making plans for the new Inner Harbor.

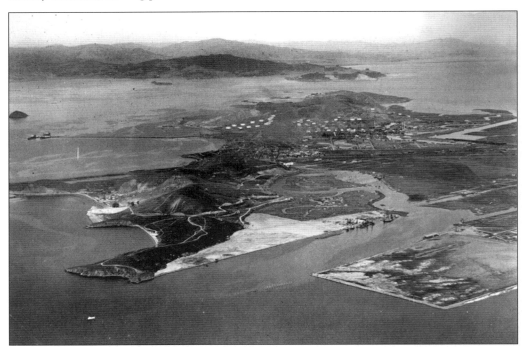

INNER HARBOR, C. 1927. The large square area at the lower right is entirely fill, and would provide the foundation for the new Terminal #3 and the Ford Plant. While some fill is visible across the channel, Potrero Point, and the cove beyond, retain their original contours.

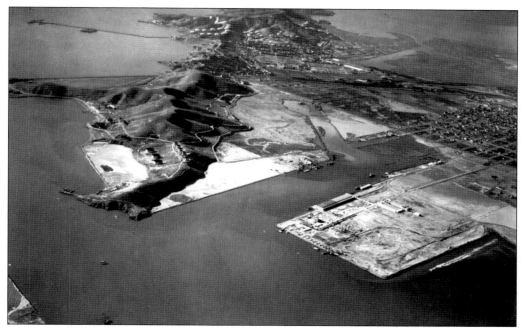

INNER HARBOR, C. 1930. The shoreline continues to change. The Parr Terminal is now built and work has begun on the Ford Plant. The area to the left of the upper Santa Fe Channel has been filled, as has been the cove just beyond Point Potrero.

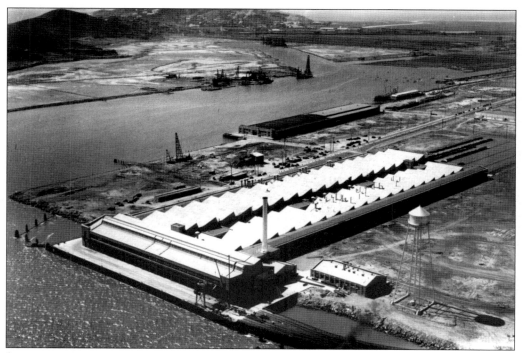

INNER HARBOR, 1931. The Ford Plant is now completed, though production has not yet begun. The plant would officially open in August, 1931, producing the Model A car.

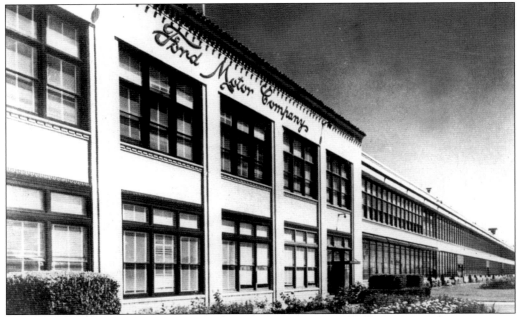

THE FORD BUILDING. Built on fill, this 560,000 square feet structure literally "floats" on 3,500 pilings. When the Ford Company ceased production here in 1955, the building fell into disrepair. It is currently undergoing reconstruction and is on the National Register of Historic Places.

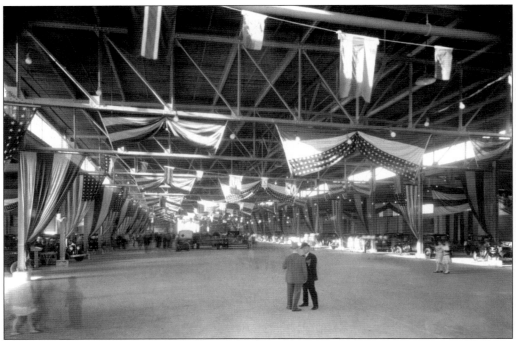

OPENING DAY CEREMONIES, FORD PLANT, AUGUST 1, 1931. 20,000 spectators attended the opening of the Ford Plant. The plant's whistle was to signal the start of operations, but the pull-cord jammed. An unidentified lad ran to waiting railroad engines, whose shrill blasts saved the day.

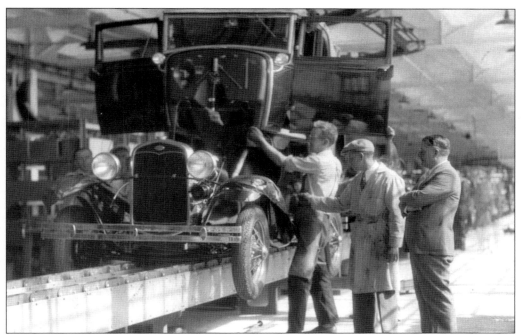

ON THE ASSEMBLY LINE. The Model A, shown here being assembled at the Richmond plant, was last produced in 1931. This facility employed 800 workers and had a capacity of 400 cars and trucks a day.

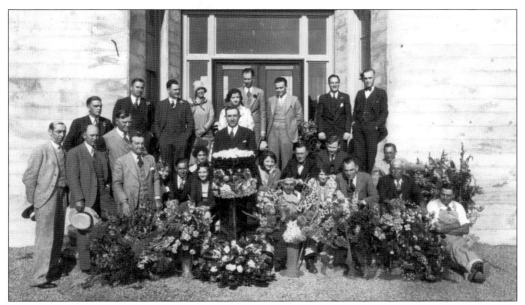

OPENING DAY, FILICE AND PERELLI CANNERY, JUNE 26, 1930. This large operation, founded by Italian immigrants, provided employment to Richmond residents (especially Italians) throughout the years of the Great Depression. At the peak of the harvest season it employed as many as 1,500 workers, mostly women. Though business has long since ended, the building still stands. It is located along Harbour Way, not far from the Ford plant.

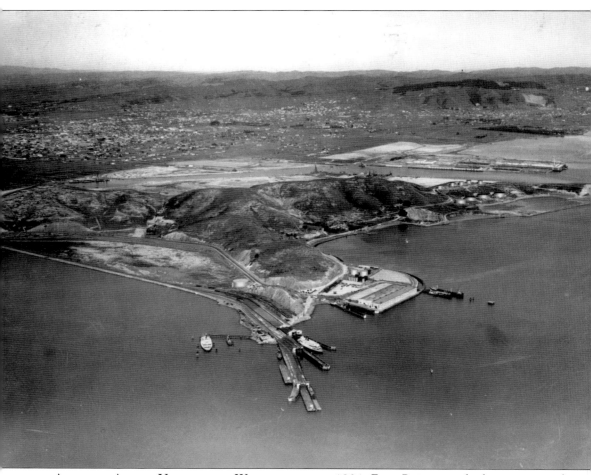

ANOTHER AERIAL VIEW OF THE WATERFRONT, C. 1931. Ferry Point is in the lower center of this picture, and to the right, Wharf (Terminal) #1. Following the shoreline to the right one can just make out the brickworks in Brickyard Cove, and beyond that the filled-in area this side of Point Potrero. The Ford Plant is across the Santa Fe Channel.

KOZY KOVE, EARLY 1930S. The shoreline was not used solely to carry on business. Kozy Kove, on the southwest shore of Point Richmond, was for years a popular place to play on a summer's day. Keller's Beach was just nearby and is still a popular destination.

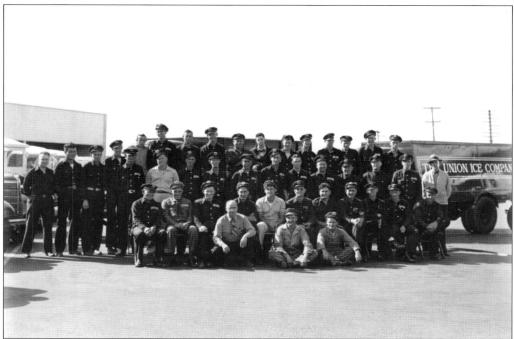

KEEPING COOL. Many Richmondites still used iceboxes in their homes and the Union Ice company served their needs. Besides the giant businesses like Ford and Standard Oil, many small and medium-sized companies helped Richmond make it through the worst days of the Depression.

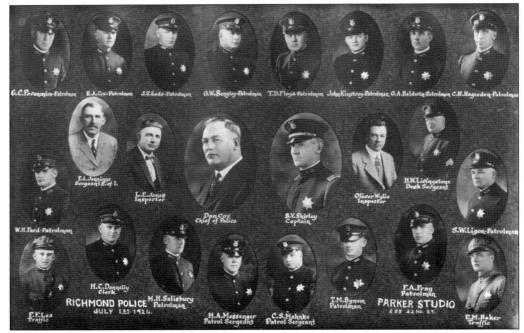

Richmond's Finest, 1926. Richmond was still a small town in 1926, having a population under 20,000. This police force would be adequate for years to come, as the number of residents grew very slowly throughout the 1930s.

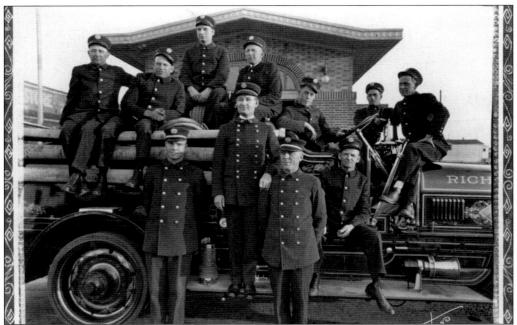

Richmond Fire Department, 1925. It was in 1915 that Richmond's firefighters relinquished their volunteer status and became full-time paid professionals. This casual, happy group seems justly proud of its shiny new truck.

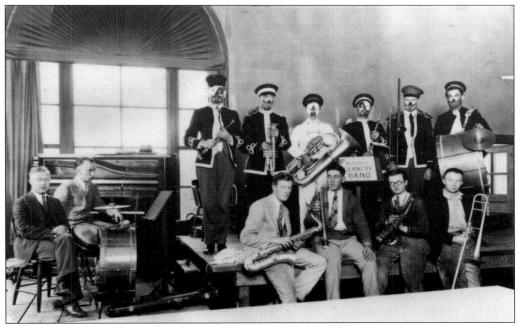

NOVELTY DAY, 1925. This band was sponsored by Standard Oil, which saw itself as very much a part of the cultural and social life of Richmond. The seated fellow with the plaid tie and the trumpet is a young Gay Vargas, who would go on to form his own band and become a fixture in the political life of the town.

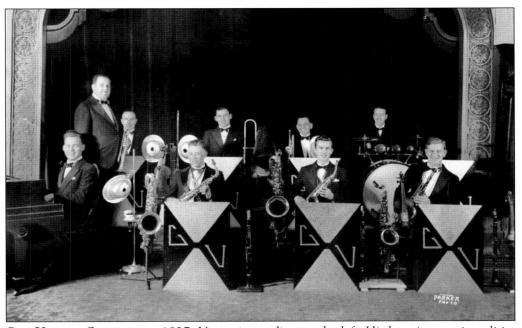

GAY VARGAS ORCHESTRA, 1937. Vargas is standing, to the left. His later interest in politics grew out of his participation in the Musician's Union, which became an important player in Richmond's political life.

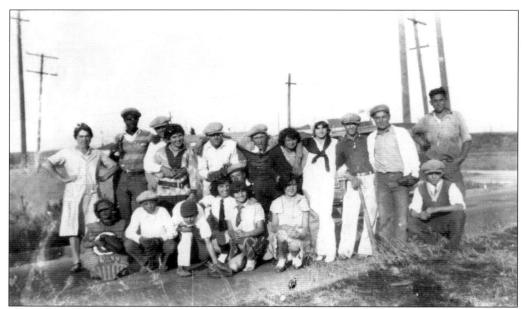

FIORE LODETTI'S BASEBALL TEAM, C. 1930. The Lodetti family settled in North Richmond, along with many other Italian Americans and most of the African Americans in town (at this time comprising no more than one percent of the total population). The young black team-mate is Walter Freeman, who learned to speak Italian "pretty good," and in turn taught English to the immigrant parents.

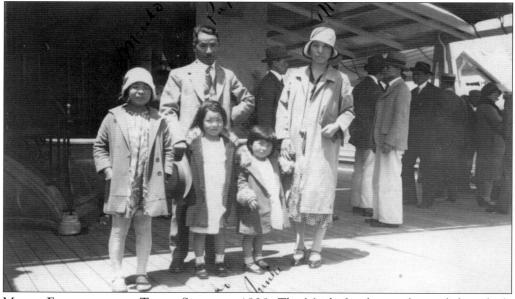

MAIDA FAMILY AT THE TRAIN STATION, 1929. The Maida family now boasted three little girls, Meriko (age 9), Asako (age 6), and Junko (age 3).

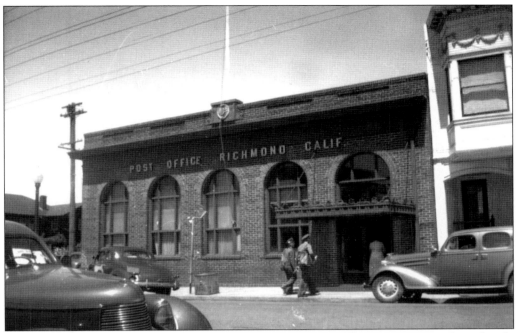

THE OLD POST OFFICE, SIXTH AND NEVIN, LATE 1930S. This picture was taken shortly before the new post office at Tenth and Nevin was built. Before the war, it was a quiet place. One resident remembers hearing nothing but the old clock ticking.

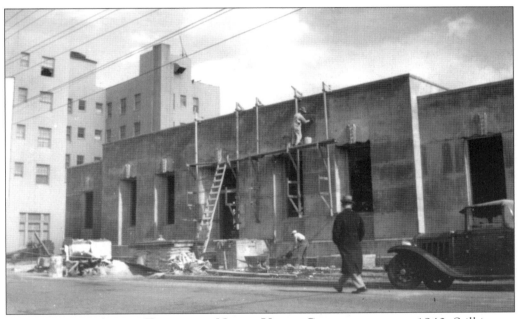

THE NEW POST OFFICE, TENTH AND NEVIN, UNDER CONSTRUCTION, C. 1940. Still in use, this building was completed just in time to take on the demands of a rapidly expanding population. Like other businesses, the Postal Service had to reach out to find more workers, hiring African Americans and other newcomers.

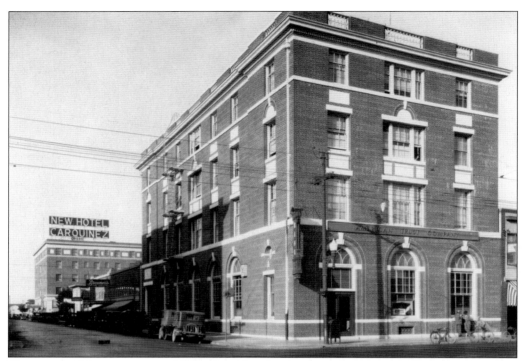

TENTH AND MACDONALD, C. 1930. Considered to be the most prestigious location in town at the time, we see in the foreground the American Trust Building (later to become Wells Fargo Bank), and beyond that the Hotel Carquinez, where all the important business in Richmond took place. The hotel is now on the National Register of Historic Places.

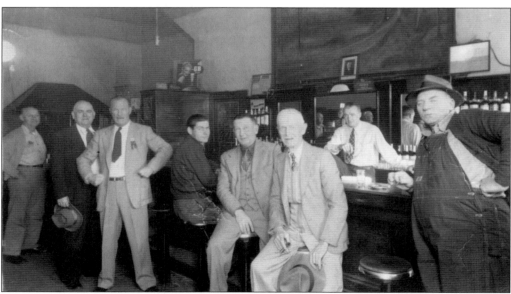

JIGGS BAR AND TAVERN, THIRTEENTH AND MACDONALD. The men's demeanor and the union sign proclaim this to be a workingman's establishment. The picture of President Franklin Roosevelt above the mirror indicates that the photo was taken some time after 1932.

MARTIN'S GRILL AND FOUNTAIN, C. 1940. Located at Tenth and Macdonald, Martin's was one of the most well-known and well-loved restaurants in town. The founder, Martin Dabovich, is standing at the right. His son Martin Jr. is wearing the white coat, and to his right is his sister Angie.

RICHMOND UNION HIGH SCHOOL, TWENTY-THIRD AND TULARE. Erected in 1928 to replace the old high school at Twenty-third and Bissell, this lovely brick structure would stand for 40 years. Very few who attended school here did not mourn its passing.

WALTER T. HELMS. Richmond's only school superintendent from 1903 to 1949 he was the "father" of Richmond's school system. He was in charge when the new high school was built in 1928 and was at the helm during the difficult years of World War II.

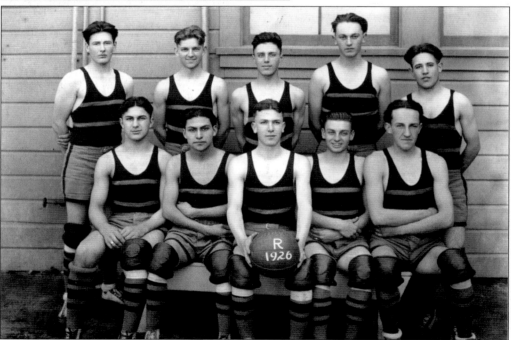

RICHMOND HIGH BASKETBALL TEAM, 1926. Like this team, Richmond was confident and maturing in the third and fourth decades of the 20th century.

CLINTON HILL, 1930. In the early days, developers sold developed lots, not houses. The area near Clinton Hill remained largely empty until the population surge of the 1940s encouraged growth across the flat land to the East Richmond and El Cerrito Hills.

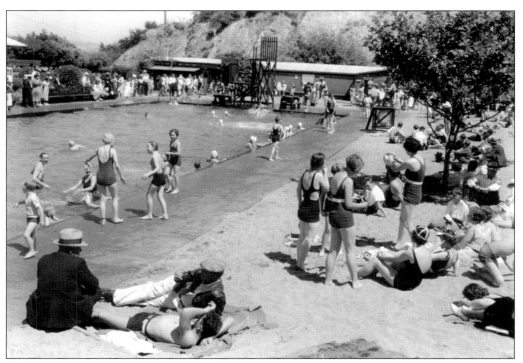

OPENING DAY, STANDARD OIL ROD & GUN CLUB, MAY 20, 1934. The club was another amenity provided by the refinery to its employees.

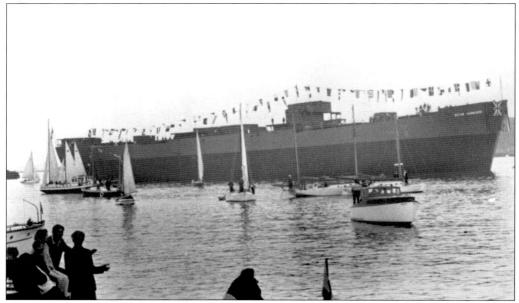

LAUNCH OF *SS OCEAN VANGUARD*, SHIPYARD #1. Built for England before America's entry into the Second World War, this ship was the first of 747 ships that would eventually be launched at Kaiser's four Richmond shipyards.

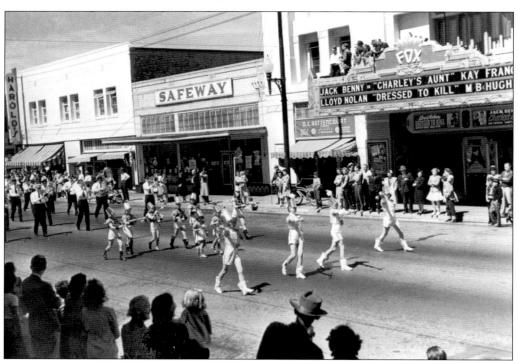

ANOTHER PARADE. It's not clear what this parade is about, but the featured films at the Fox Theater (previously the California, and before that, the T & D), place the date as 1941. In just a few months the mood would become more serious as America, and Richmond, went to war.

Five

BOOM!

THE WAR YEARS

According to Shirley Ann Wilson Moore, author of *To Place our Deeds*, a history of the African-American population in Richmond, "the war boom hit Richmond like no other town in the United States." At the war's beginning the population stood at around 23,000. In a little over two years the population had quadrupled and was still rising. People were streaming into Richmond from all over the country, but principally from the Midwest and South, to work in the Kaiser-Permanente shipyards. To meet their housing needs, 24,000 housing units (mostly temporary) were built, but this was not enough to meet the demand. People slept in rented-out rooms, garages, trailers, barns—whatever was available. Since work at the shipyards was round-the-clock, employees sometimes rented beds for eight hours at a time, sharing them with other renters on different shifts. Like the yards, downtown Richmond never slept, many businesses, especially theaters, remained open at all hours to accommodate the restless or resting laborers. Demand for everything was huge, and everything, because of the war, was in short supply. Lines were everywhere, at banks, restrooms, grocery stores, and gas stations. Richmond, it seemed, had finally hit the big time.

The workers seldom came alone. They brought their families. Suddenly a school system that had actually seen a drop in attendance during the 1930s was faced with a tripling of the school population. It was impossible to build new schools fast enough to meet this surge in demand, and, in any case, most of the available money was going into war production, not social services. Schools adjusted by going into double or triple sessions. Incredibly, a few schools even ran quadruple sessions. The strain on the facilities and the staff was enormous, and the system might well have broken down had it not been for the steadying hand of Walter T. Helms. Since 1903 he had been the only superintendent the Richmond Schools had known, and by the 1940s he was an old man, approaching a well-deserved retirement. But this tall, quiet man, physically and mentally strong, managed to keep his over-worked staff focused on the job at hand, through the war years and into the difficult years beyond.

By the end of four years of war, Richmond was a changed town. What had been a settled working-class community was now a formless assemblage of residents with limited skills and education, of largely rural background. Many were African-American. Before World War II, the African-American population had been small—no more than one percent of the total. By the war's end, that figure had risen to around ten percent and would continue to grow. Most of the newcomers, not just those of African-American descent, were met with a certain degree of suspicion, resentment, and prejudice, for they had brought with them not just themselves but their cultures. Everything, from music to food, was new and strange. And, unfortunately, hostility is often the reaction to the unfamiliar. It would take a long time—decades in fact—for the unfamiliar to become the background of life in a new Richmond. The years since the end of the Second World War were largely ones of adjustment;and an adjustment, that some might say, is still going on.

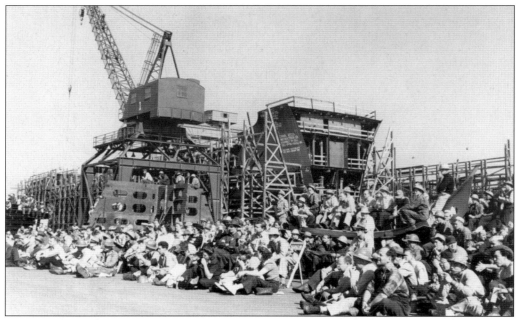

A DAY AT THE SHIPYARDS. Once America entered World War II, the Kaiser Shipyards shifted into high gear. Four large yards were built in quick succession, turning out a total of 727 ships of all types, including Liberty and Victory Ships. The group pictured here is probably listening to a "pep" talk or a safety lecture.

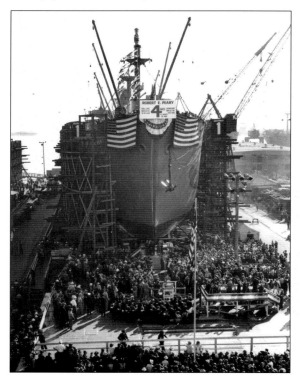

THE LAUNCH OF THE *ROBERT E. PEARY*, NOVEMBER 12, 1942. The Kaiser Shipyards established a world record on this date when it launched the *Peary* (a Liberty Ship) in the astonishing time of 4 days, 15 hours, and 29 minutes.

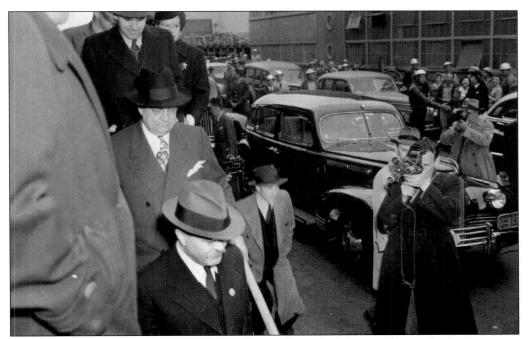

THE RUSSIANS ARE COMING! So impressive were Kaiser's skills at efficient shipbuilding that the Soviet Government sent its two top officials, Andrei Gromyko and Molotov to have a look. Kaiser is the man in the middle. This picture was taken at Shipyard #3.

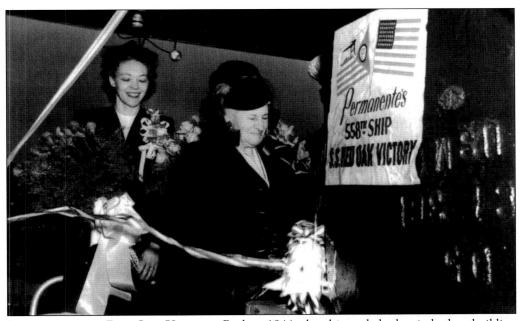

LAUNCH OF THE *RED OAK VICTORY*. By late 1944, the shipyards had switched to building Victory Ships, larger and faster cousins to the Liberty Ships. The *Red Oak* (named after the town of Red Oak, Iowa) was launched in November of that year. The ship is now owned by the Richmond Museum Association and is on the National Register of Historic Places.

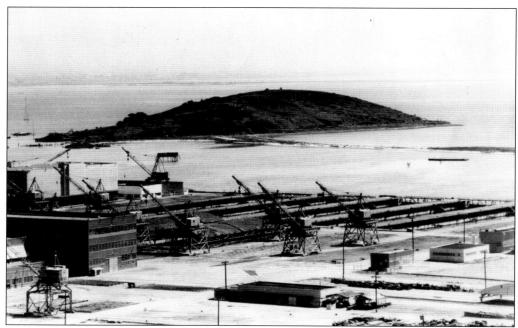

SHIPYARD #3. Early in 1942, the tip of Point Potrero was completely leveled to create this shipyard. It is unique in that vessels were constructed, on the level, in huge concrete basins that were simply flooded when ships were ready for launch. It is also the only yard still in operation and is on the National Register of Historic Places.

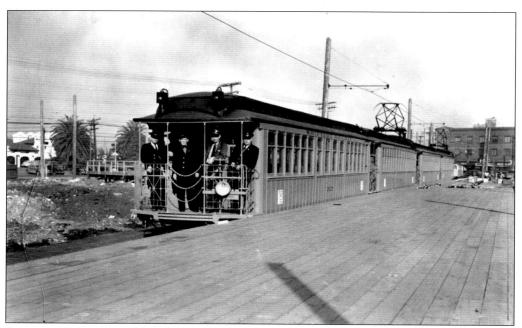

SHIPYARD RAILWAY. In order to move his workers efficiently to and from the work site, Kaiser bought old New York electric train cars and shipped them to the west coast. They moved workers from areas as close as Richmond to as far away as Oakland.

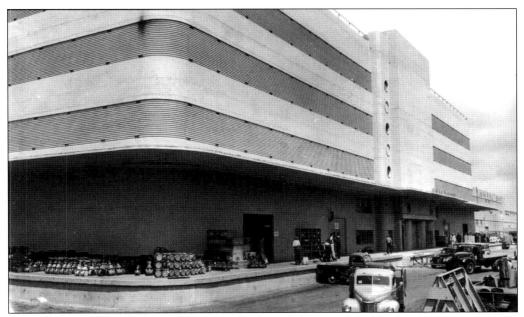

THE GENERAL WAREHOUSE BUILDING. Built in February of 1942, this immense concrete structure still stands within the grounds of Shipyard #3.

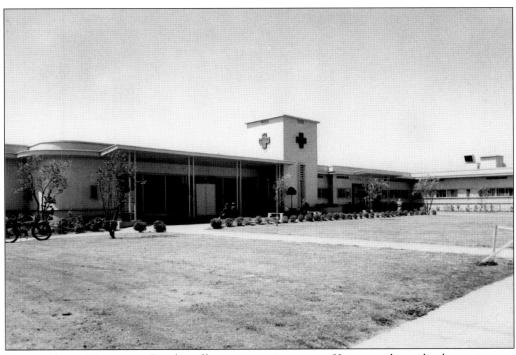

KAISER FIELD HOSPITAL. Besides offering attractive wages, Kaiser made medical coverage an incentive to join his work force. This hospital, at the corner of Cutting and Fourteenth (now Marina Way), operated for years, long after the war ended. Replaced by a much larger Kaiser-Permanente facility, this building is now shut down.

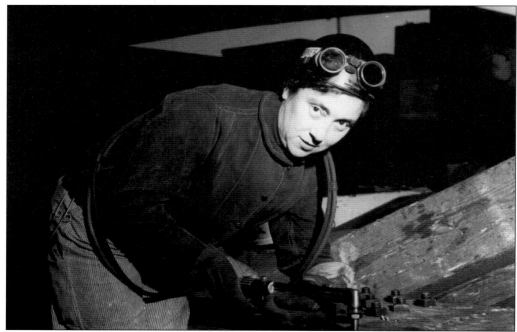

BURNER. Women constituted almost one-third of the work force at the Richmond shipyards. A burner cut metal plates with a cutting torch and wore goggles (not a mask).

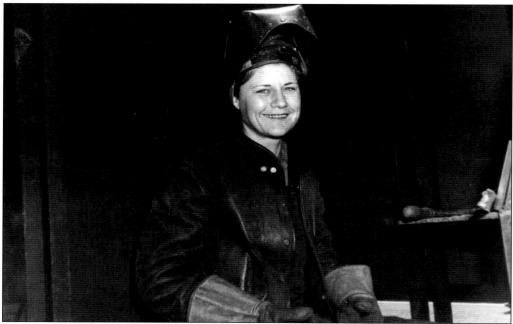

ARC WELDER. Though female workers have acquired the generic term "Rosie the Riveter," few, if any, worked with a rivet gun. By far, the majority of women were trained to weld. Therefore, "Wanda the Welder" might be a more appropriate term. This young lady is identified as the runner-up in the "Joan of Arc" contest.

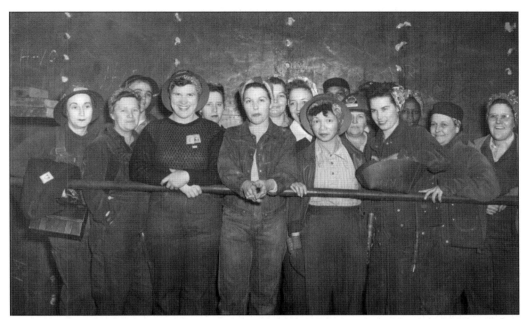

A HAPPY GROUP. This diverse grouping of welders and ship-fitters exudes the confidence that comes from tackling a daunting and unfamiliar task, and mastering it.

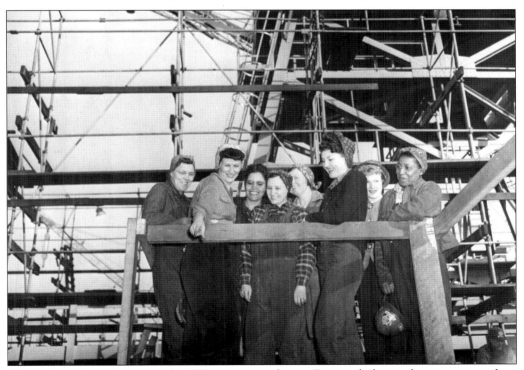

WHAT ARE THEY LOOKING AT? We may never know. But we do know that women workers were an absolutely essential part of the shipyard work force, shattering old myths about just what was the true nature of women's work.

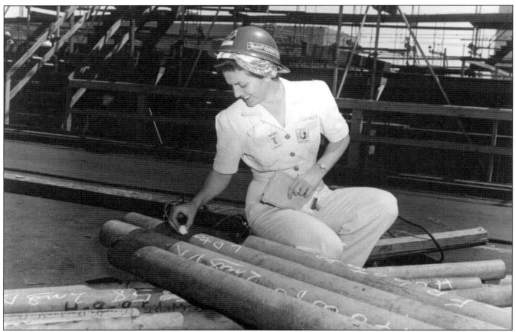

KEEPING THINGS MOVING. The expediter's job was to ensure that work flowed smoothly, without unnecessary bottlenecks and interruptions.

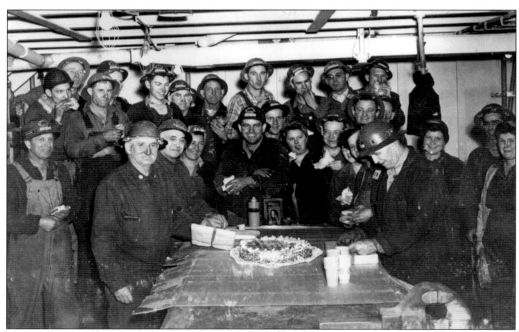

"THE STRANGER WAS NOT STRANGE FOR LONG." Work at the Richmond yards went on 24 hours a day, without letup. But it was moments like these, a few minutes to celebrate some personal or group achievement, that formed the bonds of trust and friendship that would last, not only for the war, but for a lifetime.

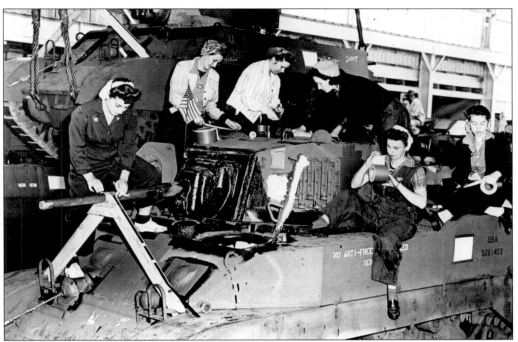

PREPARING TANKS FOR SHIPMENT AT THE FORD PLANT. During the war, women worked in many industries that had been considered to be all-male, including the auto assembly line. But tanks were not actually built at the Ford plant, just prepared to be shipped overseas.

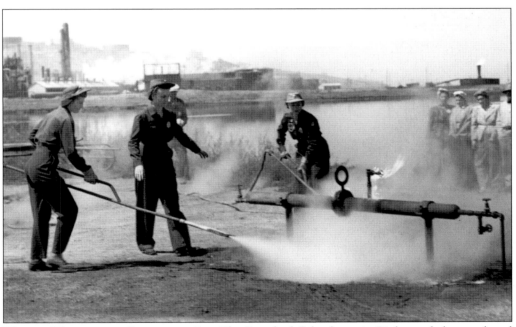

WOMEN WORKERS AT STANDARD OIL. The Standard Oil refinery in Richmond also employed women in traditionally male jobs during the war. These workers are practicing the techniques of proper fire suppression.

SHIFT CHANGE, STANDARD OIL COMPANY. Like the shipyards, the oil refinery was a round-the-clock operation, which had difficulty in meeting the demands imposed by higher output and a reduced pool of available man (or woman) power.

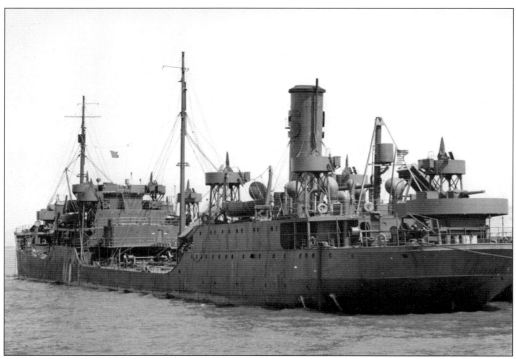

SS R.J. HANNAH. The *Hannah* was a Standard Oil tanker. Here she is seen painted a war-time gray, and equipped, like the Liberty and Victory Ships, with bow, stern, and anti-aircraft guns.

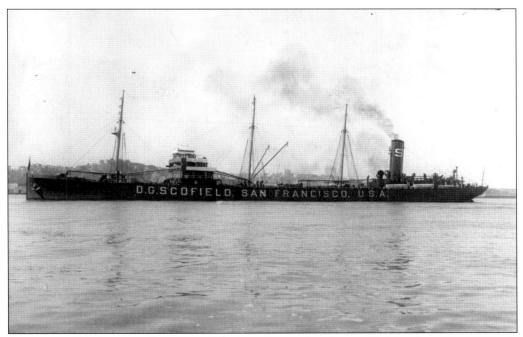

STANDARD OIL TANKER SCOFIELD. The *Scofield* was already an old ship when World War II broke out, but continued to be of service. That service ended in the Indian Ocean, when the *Scofield* was struck by an enemy torpedo and sunk.

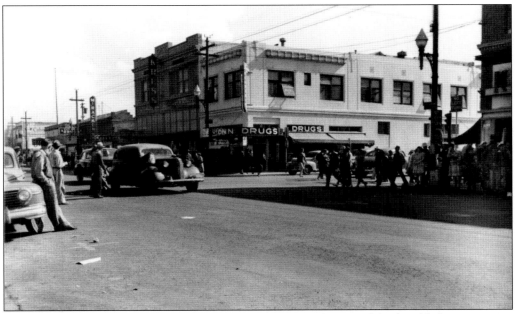

DOWNTOWN RICHMOND, LOOKING EAST FROM TENTH STREET. Macdonald Avenue was a busy street during the war, as this picture shows. Martin's Grill had now moved into Conn's Drugstore, which later moved to Twenty-third and Macdonald. The Kress Store was a favorite place to shop long after the war ended.

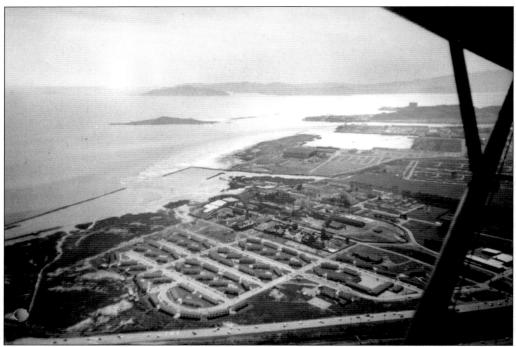

WARTIME HOUSING. Something like 25,000 housing units were built during the war to shelter Richmond's new residents. Some had names. This is the Seaport complex, built on marshy land close to the bay. In the distance to the right can be seen Shipyard #2.

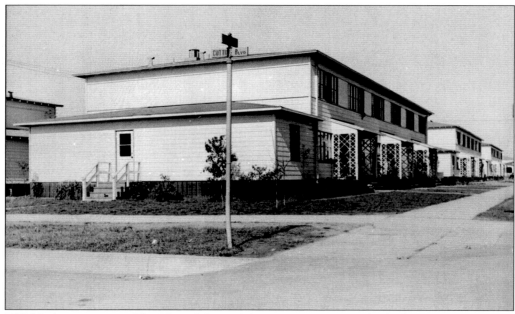

USMC APARTMENTS. The United States Maritime Commission built thousands of housing units in Richmond, mostly on the Southside. The homes pictured here stood at the corner of Cutting Boulevard and South Sixteenth Street.

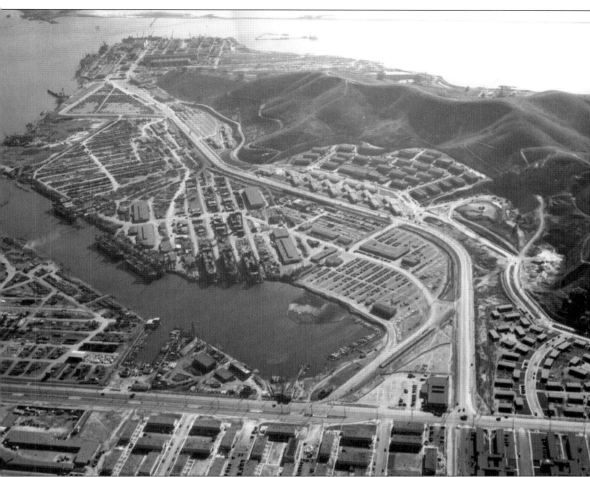

THREE SHIPYARDS AND WAR HOUSING. Clockwise from the left we see Shipyard #1. Across the Santa Fe Channel is Shipyard #4, which was the last yard built and which launched specialized ships, such as frigates, LST's, and "pint size Liberty's." Out at the end of Point Potrero we can see Shipyard #3. Coming around further to the right we see the Terrace Apartment complex, nestled against the hills of Point Potrero. Across Canal Street, along the border of Shipyard #4 are some USMC housing units. In the lower right hand corner is the small Esmeralda housing complex, and at the intersection of Canal and Cutting is the West Campus to the Contra Costa Junior College. Across Cutting Boulevard is the sprawling Canal housing project.

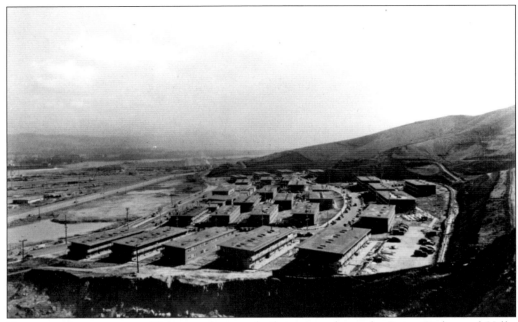

TERRACE APARTMENTS. This complex was built against the rocky Point Richmond Hills, along Canal Boulevard. Across the road is Shipyard #4. Shipyard #3 was (and is) located at the end of Canal.

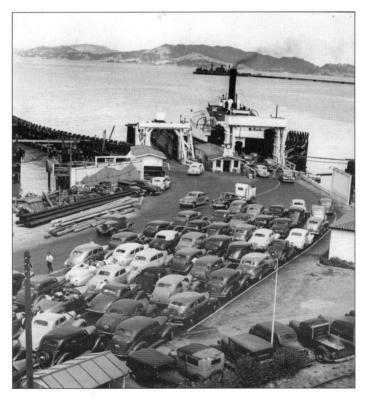

THE RICHMOND–SAN RAFAEL FERRY DURING WARTIME. The thousands of new residents put a severe strain on all Richmond's services, including transportation. The wait for a ferry to or from San Rafael was often a long one.

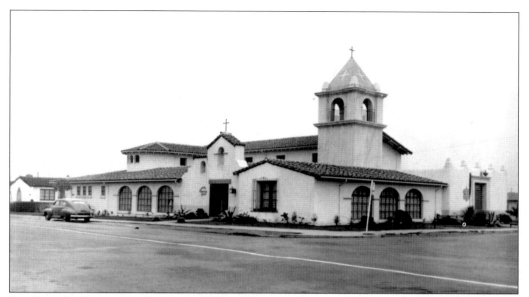

ST. LUKE'S EPISCOPAL CHURCH. Before the war, there were three Episcopal Churches in Richmond. Wesley and Central Churches decided to pool their resources and build a single new structure on the outskirts of Richmond, at Thirty-second and Barrett. The outbreak of war slowed but did not stop the building, and on February 1, 1942, the first service was held. The tiles for the church altar were donated by the owners of the California Art Tile Company of Richmond.

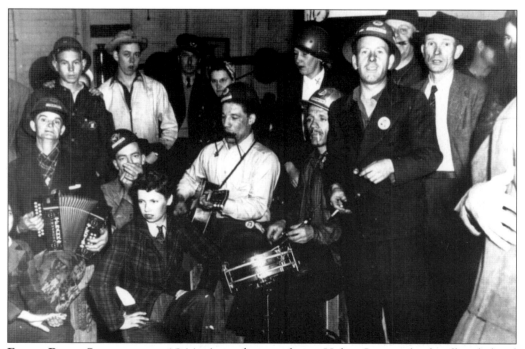

FERRY BOAT SWINGSTERS, 1944. According to donor Helen Swartz, (in hardhat behind drummer) these musician-workers would play and sing on the 6 am ferry from San Francisco to Richmond.

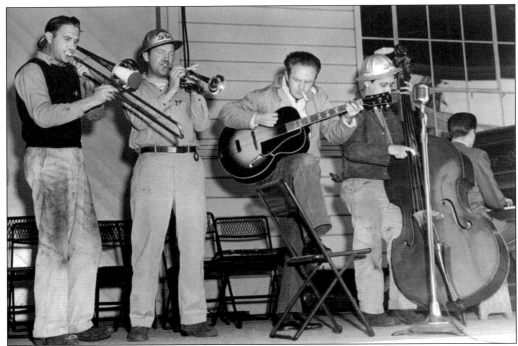

McCauley Brothers Band, April 21, 1944. Ship launches were frequent and so was the entertainment that accompanied them. Like many musicians in Richmond (Gay Vargas included), the McCauley brothers were members of Musicians Local 424.

Rafting in Shipyard #2. While in the background ships are built for war, these boys find an opportunity for just plain fun.

Six

REALITY CHECK
THE POST-WAR YEARS

By 1946 Richmond faced problems even greater than those tackled during the war years. Its population quintupled and the jobs that had attracted its new residents suddenly evaporated. The skills acquired in the shipyards were limited, specialized, and not easily transferable to the local market. Most of the housing built for these "temporary" workers was itself temporary, and slated to be razed. The city's social, police, fire, and school systems were all strained to the limit. Richmond needed a new city hall, jail, and library, all of which were badly overcrowded. But resources were in short supply.

The city administrators had naively hoped that, once the crisis of war had subsided, the "temporary" workers would go home, and thereby solve their problem. Some did, but most did not. Those that did go home usually returned, often with even more family members or friends in tow. For whatever problems they had found in their new home, it still seemed to be better than the place they had come from. Many had simply forgotten what a summer in the Mid-West or South could be like, and thankfully returned to the cool breezes of this city by the bay. Simply put, at the end of three or four years, the workers' families had put down roots and formed attachments that could not easily be broken. For most of these "temporary" workers, Richmond had become a permanent home.

The period from the war's end through the 1950s was a time both of growth and destruction, of renaissance and decline, a moment within the living memory of local residents that is recalled with nostalgia, warmth, and sadness. In 1949 Richmond's Redevelopment Agency was formed and began to plan for the city's post-war transformation. In that same year a new civic center was built, one of the most modern such structures built in the country, and which led to Richmond garnering the title "All American City" in 1952. But nothing is gained without loss, and in that same year of 1949, the grand old Nicholl Building, which had served as Richmond's city hall since 1917, was torn down.

New projects were born, while others were swept away. Easter Hill, an innovative and revolutionary approach to planned housing, was built. At the same time most of the war-time housing was torn down, leaving many residents hard-pressed to find affordable shelter. These displaced residents were largely of African-American descent, and it was during this time that their voices began to be heard. Their images were skillfully captured by one of their own, a photographer by the name of Ellis Myers, whose work is gratefully displayed in this next chapter.

The City of Richmond encouraged new growth beyond its borders, especially in El Sobrante, and began an annexation process that continued for decades. The downtown remained unchanged and it continued to attract shoppers and club-goers throughout the 1950s. Whatever else was happening in Richmond, Macdonald Avenue was still the place to be, and be seen.

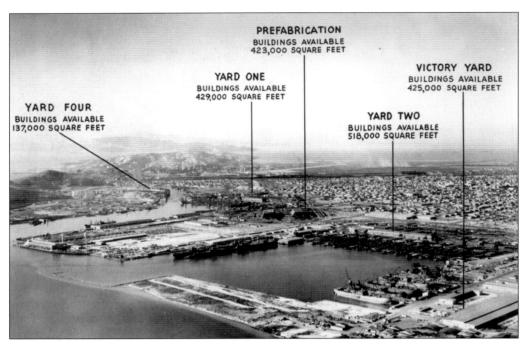

PREFABRICATION
BUILDINGS AVAILABLE
423,000 SQUARE FEET

YARD ONE
BUILDINGS AVAILABLE
429,000 SQUARE FEET

VICTORY YARD
BUILDINGS AVAILABLE
425,000 SQUARE FEET

YARD FOUR
BUILDINGS AVAILABLE
137,000 SQUARE FEET

YARD TWO
BUILDINGS AVAILABLE
518,000 SQUARE FEET

SHIPYARDS FOR SALE. With the end of the Second World War, ship-building in Richmond stopped abruptly, as did much of the revenue needed to maintain the city's services. Here we see an effort to attract new business to the now-silent yards.

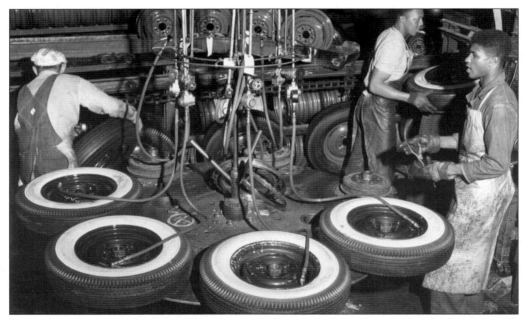

FORD PLANT, 1947. Luckily, other large employers, such as Standard Oil, the Santa Fe Railroad, and the Ford Plant, continued to operate and offer employment after the end of the war. Ford executives however, were increasingly unhappy with the Richmond site, and the last automobile rolled off the Richmond Plant line in 1955.

94

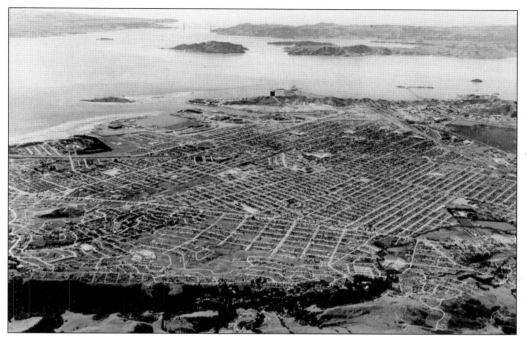

RICHMOND, 1950. By this date Richmond had filled in the area from the shore-line to the Mira Vista Hills. Most of the war housing, however, still visible in this picture, would soon be torn down.

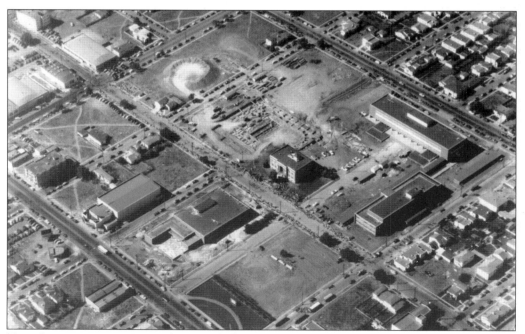

THE OLD AND THE NEW. This aerial photograph was taken on September 19, 1949, and shows the new city hall and the hall of justice (upper right and right), along with the old city hall (center). A dedicatory parade is moving along Nevin Avenue, significantly, by the old building, not the new.

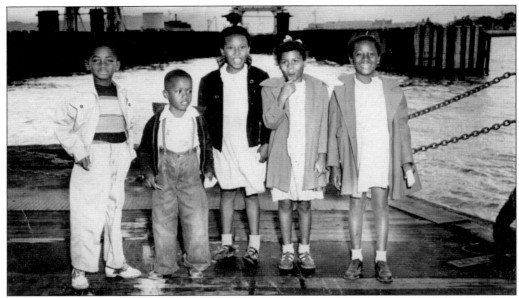

ANOTHER ERA COMING TO AN END. These happy kids are aboard one of the Richmond–San Rafael ferries, just pulling away from the San Rafael slip. The date is some time in the early 1950s, and the new Richmond–San Rafael Bridge will soon make such scenes a part of the past. (Courtesy Myers Collection, Richmond Museum Association.)

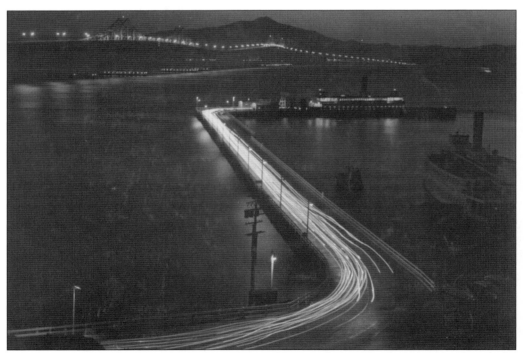

NIGHT SCENE AT THE FERRY TERMINAL. As can be seen, the new bridge is built and ready for operation. The year is 1956 and the old ferry has only a few days left to run.

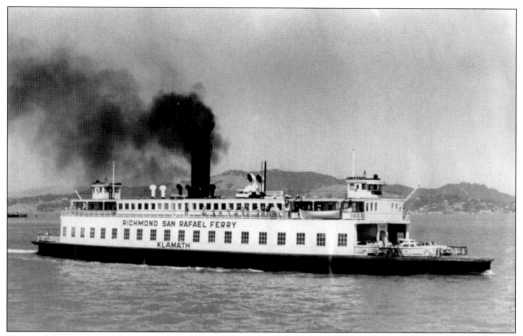

FERRY KLAMATH. This picture was taken on the last day of operation of the Richmond–San Rafael ferry system, Sunday, August 26, 1956.

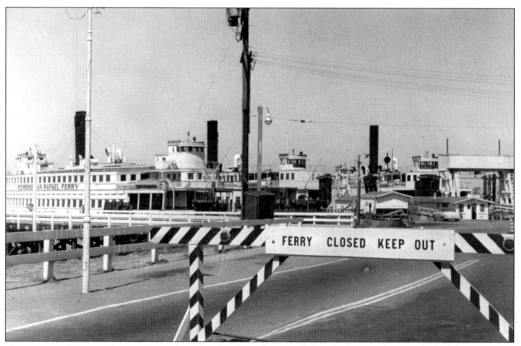

AWAITING THEIR FATE. Out of a job, the ferry boats of the Richmond–San Rafael line sit idle at the Richmond terminal at Castro Point. The three closest boats, from left to right, are the *Sierra Nevada*, the *Klamath*, and the *Russian River*.

HARBOR GATE HOUSING, JULY 23, 1953. This complex, consisting of just over 800 units, was located just east of Shipyard #2 (where the Richmond Marina is today). It had its own school, which can just be seen in the distance. Shortly after this picture was taken, these homes were demolished.

ELLIS MYERS, PRIVATE FIRST CLASS, GUADALCANAL, C. 1944. Following their marriage in 1947, Ellis and Esther Myers set up housekeeping in the Canal Apartments, off Cutting Boulevard. It was there that Ellis began his career as a photographer, doing his own developing in the kitchen. Many of the following photographs are courtesy of Mr. Myers.

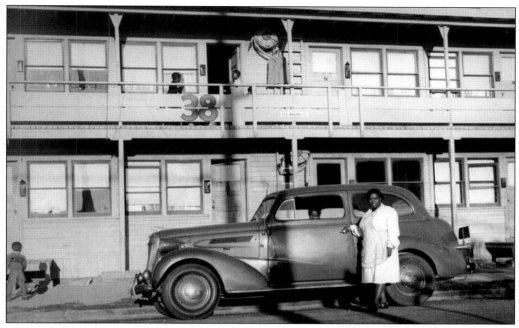

MOTHER SPAN, 1947. Richmond's war housing was, to a large extent, racially segregated. "Mother" Span and a group of like-minded religious and civic-minded women took it upon themselves to minister to the religious and practical needs of African Americans still housed in these rapidly aging structures. (Courtesy Myers Collection, Richmond Museum Association.)

BASEBALL TEAM, C. 1950. Team sports were popular and a source of identity and group cohesiveness for African-American youngsters in post-war Richmond. Participation also underscored their connection to the wider culture. (Courtesy Myers Collection, Richmond Museum Association.)

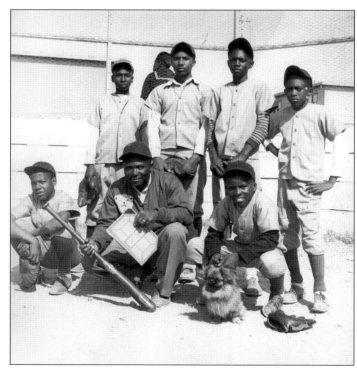

CANAL STREET MARKET, C. 1950.
Located at 305 Canal Street, this
small store, among others, served the
residents of the sprawling Canal
Apartment complex, whose residents
were mostly African American.
(Courtesy Myers Collection,
Richmond Museum Association.)

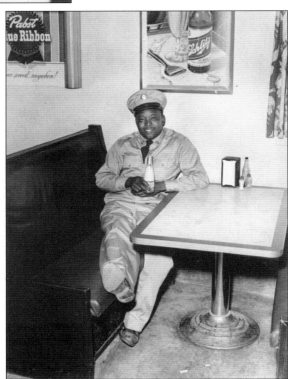

KING'S MODERNETTE RESTAURANT,
1950. Located at 269 Canal Street, and
run by Mrs. Cleo King, this was a
popular hangout for the Canal Housing
residents. (Courtesy Myers Collection,
Richmond Museum Association.)

JOSHUA SPAN, CANAL HOUSING PROJECT, JUNE 23, 1950. Clearly proud of his fishing prowess, Mr. Span exemplifies the self-reliant spirit that many of Richmond's rural immigrants brought with them. (Courtesy Myers Collection, Richmond Museum Association.)

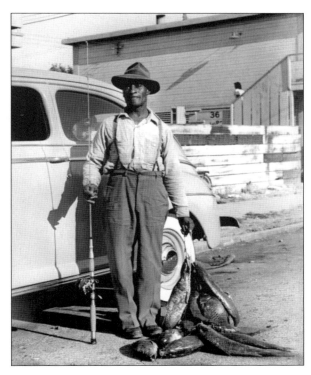

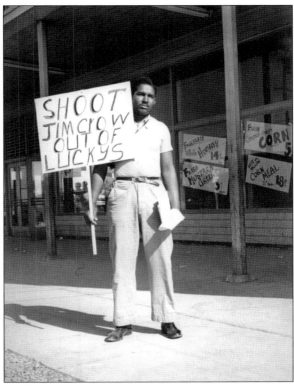

LUCKY STRIKE, 1949. This Lucky store, at 1528 Cutting Boulevard, was willing to sell to its black customers but not to hire them. The protest, and the associated litigation, reaching all the way to the state supreme court, resulted in the hiring of five black clerks by Lucky. (Courtesy Myers Collection, Richmond Museum Association.)

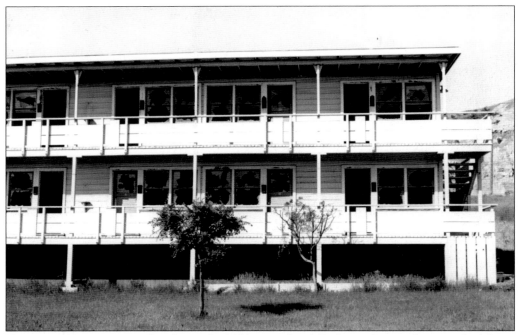

TERRACE APARTMENTS. By the early 1950s, much of Richmond's war housing had been abandoned to the elements and vandals, as is evident in this photograph taken March 1952.

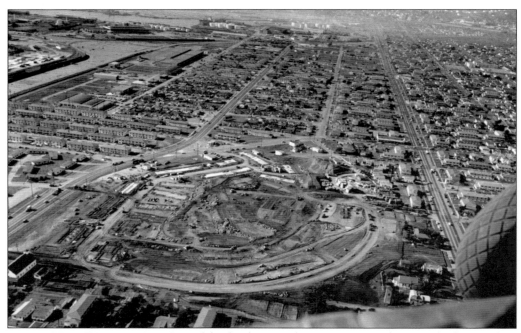

EASTER HILL, EARLY 1950S. One of the few low-cost housing projects that were built to replace the war-time housing, Easter Hill was ground-breaking in many ways, employing people-friendly design elements which are now accepted practice but were quite radical at the time. The project has been nominated for placement on the National Register of Historic Places.

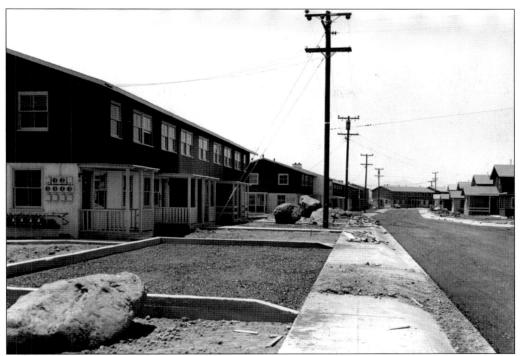

EASTER HILL, JULY 21, 1954. Construction is almost complete. Notice how the boulders, natural to the site, have been retained to create garden focal points and general points of interest.

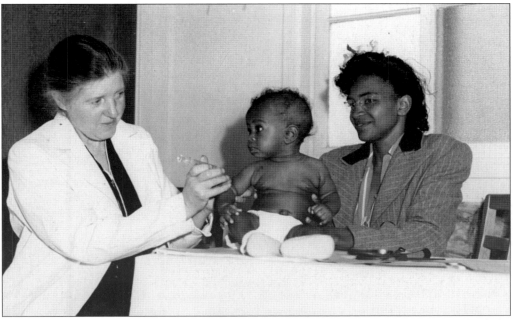

THIS WON'T HURT, RIGHT? As in the rest of the country, Richmond experienced a baby boom in the years following World War II. This veteran's baby is being immunized in one of the child-care centers located in the public housing area.

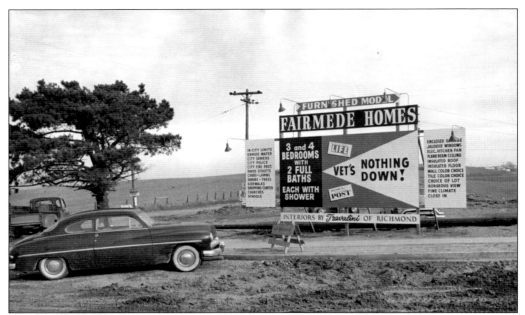

New Development. In the 1950s Richmond began to expand and to encourage growth in the hill areas surrounding the older area of town. In and around El Sobrante pieces of land were annexed to the city and developed, often with fanciful names. "Sherwood Forest," for instance, was begun in 1954.

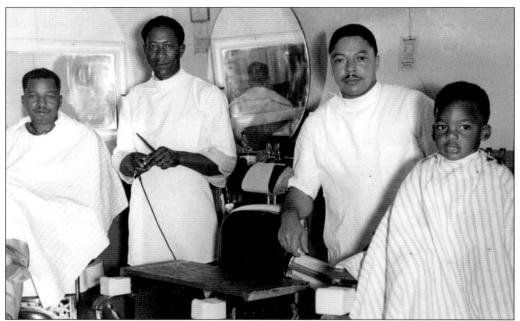

Parchester Village Barbershop, c. 1952. Completed in 1950, Parchester Village was initially conceived as an integrated community, but whites proved reluctant to move in. Annexed to the city in 1963 the Village has developed a strong sense of identity and political awareness. (Courtesy Myers Collection, Richmond Museum Association.)

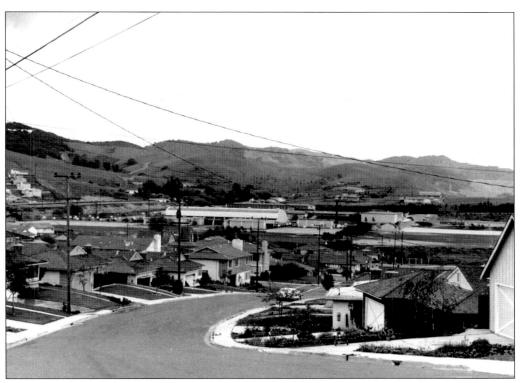

DE ANZA HIGH SCHOOL. With the new housing going up in El Sobrante, new schools were needed. De Anza High, seen here from the new "Whitecliff Estates," opened in 1955 and served grades 7 through 12.

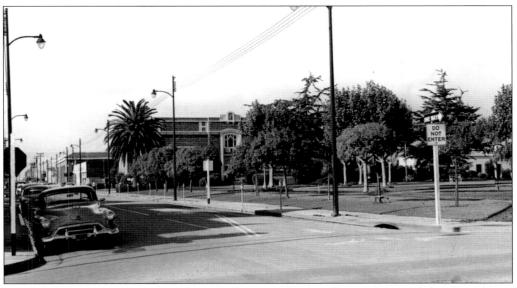

MEMORIAL PARK, APRIL 27, 1956. This large outdoor park, complete with bandstand, was located along Bissell Avenue between Eleventh and Thirteenth Streets. Much of the area has been taken up by housing, but a part of the park still remains as open green space.

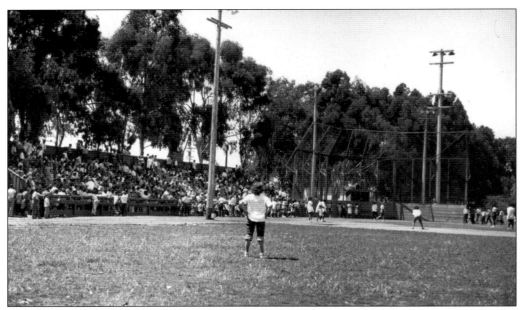

SUMMERTIME IN NICHOLL PARK. Nicholl Park, located alongside Macdonald Avenue between Twenty-ninth and Thirty-second Streets, was a very popular destination in the years following the war. It even boasted a small zoo and a train ride. Here, spectators watch a game of girl's baseball, June 1947.

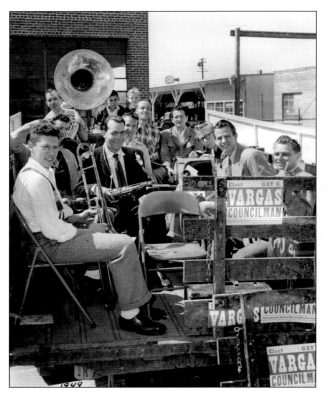

THE BOYS FROM MUSICIAN'S LOCAL 424 CAMPAIGN FOR GAY VARGAS, 1949. The man on the far right is John Temby, who had his own band and was well known in Richmond.

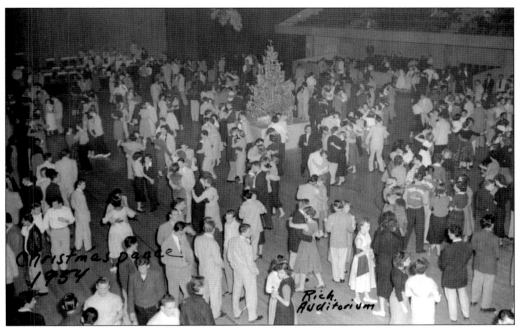

CHRISTMAS DANCE, RICHMOND AUDITORIUM, 1954. Opened in 1952, the new auditorium quickly became the place to hold the community's significant events, including school dances and graduations.

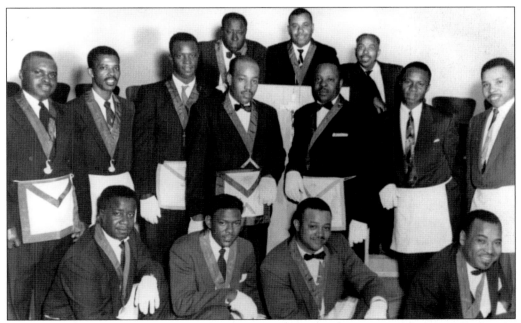

MEN OF THE MASONS, 1957. Black Richmondites had been active in the Masonic organization since 1921, and an Elks Club had been founded in the 1930s. These groups provided a recreational outlet for African-American men and raised money for the community's needs. (Courtesy Myers Collection, Richmond Museum Association.)

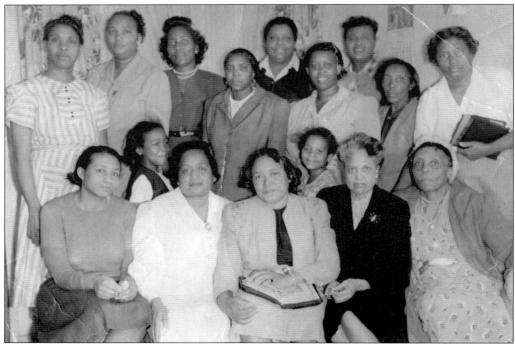

NORTH RICHMOND BAPTIST CHURCH MISSION GROUP, LATE 1940S. Women's groups were always important in serving Richmond's African-American community. Mother Span is fourth from the right, standing. (Courtesy Myers Collection, Richmond Museum Association.)

NORTH RICHMOND BAPTIST CHURCH ANNIVERSARY, C. 1950. This church on Filbert Street in North Richmond is the oldest black Baptist church in Contra Costa County. Reverend Watkins, shown here, gave a good old-fashioned sermon, "real back home Baptist Church preaching," as Walter Freeman recalled. (Courtesy Myers Collection, Richmond Museum Association.)

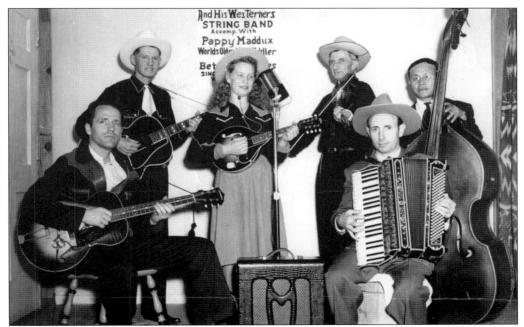

TEX AVERY BAND. With the influx of people from the Midwest and South, demand for Country & Western music naturally grew. The Avery band was just one of many that catered to these new West Coast residents. "Tex" is the man standing with the guitar on the left. The man with the fiddle is "Pappy" Maddux.

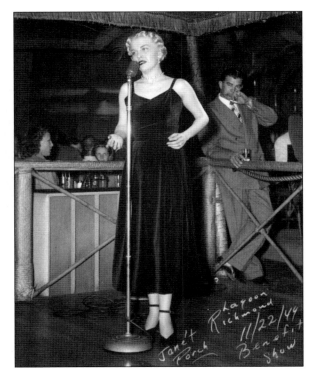

LAGOON CLUB, 1949. Janet Porch is the singer being eyed by the gentleman in the background. This popular nightclub sported a "tiki" atmosphere, and was located near the Hotel Don, at 920 Nevin Avenue.

GORDON'S DRIVE-IN, EARLY 1950S. After "dragging the main" on Macdonald Avenue, Gordon's, at the corner of Twenty-third Street and Wendell Avenue, was the place to meet for burgers, fries, and a milkshake.

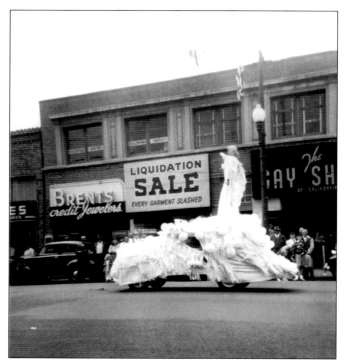

RICHMOND'S GOLDEN JUBILEE, 1955. In 1955 Richmond turned 50 and celebrated with a parade down Macdonald Avenue. The clothing shop in the background is celebrating in its own odd fashion. The sign over the window reads: "Every Garment Slashed."

Seven

MODERN RICHMOND
1960–PRESENT

In the last 40 years Richmond has continued to undergo change, though perhaps not so overwhelming as that experienced during the Second World War. Since the end of the war, population slowly but steadily declined, reaching a low of around 72,000 in 1960. That figure remained relatively stable until the late 1980s, when new housing growth drove the population back to near its post-war high of 100,000. That housing and population growth was stimulated by several major developments.

Perhaps the most well-known of these developments was the Hilltop Regional Shopping Center. The opening of this 1.3-million-square-foot facility in 1976 spelled the doom of Richmond's old downtown area, struggling since the early 1970s. With the disappearance of its major businesses Macdonald Avenue ceased to be the commercial and, in a sense, "spiritual" center of the city. And what was to replace that center was not clear. Hilltop Mall was shiny and new, to be sure, but it seemed to lack the "soul" of the old downtown.

At about the same time, the Harbour Redevelopment Project began to transform the city's waterfront, particularly the area around Shipyard #2. Where rusting cranes and docks had been, there was built a 1,500-berth marina, surrounded by green-space, housing, walkways, parks, lagoons, restaurants, and office space. It was as if Richmond had awakened to the fact that its shoreline need not be a neglected, aging, ugly duckling, but the seat of its future, a natural magnet for people, parks, and business. Even the city offices have moved (at least temporarily) to the Marina Bay area, while they await the rebuilding of the old city hall, undergoing seismic retrofitting.

The completion of the Hoffman (Knox) Freeway naturally stimulated growth in the city's southern shoreline. This new roadway connects Interstate 80 with the Richmond–San Rafael Bridge, and its many interchanges have encouraged high-tech businesses to locate in the new Marina Bay's business park, while making commuting less stressful for the area's new residents. The newest development has been the construction of the Richmond Parkway, a landscaped expressway connecting Point Richmond and the bridge with the Hilltop area. The opening of this roadway has spawned increased interest in Richmond's northwestern areas. Several new housing developments have sprung up along this corridor.

Richmond's population, always diverse, has also continued to change. The last 20 years has seen an increase in the Asian and Hispanic populations, which together comprise about 22 percent of the total. The African-American population has declined somewhat, but is still over 40 percent of the total. Whites and a smattering of other groups comprise the balance. But whatever the mix, Richmond retains its unique cultural flavor, which is constantly enriched by the dynamic interaction of its various ethnic groups.

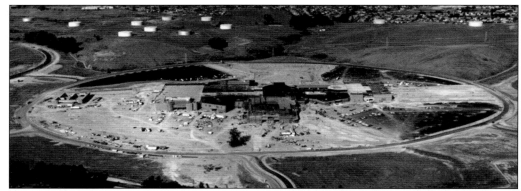

BUILDING HILLTOP SHOPPING CENTER, 1975. Years in the planning, the opening of this combination retail, business, and residential complex dramatically altered the direction of Richmond's economic development, not the least along its old business corridor, Macdonald Avenue.

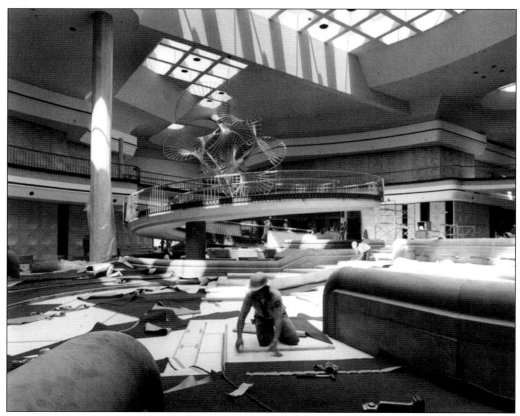

HILLTOP, JUST BEFORE OPENING, 1976. These workers are applying the finishing touches to the interior of the mall.

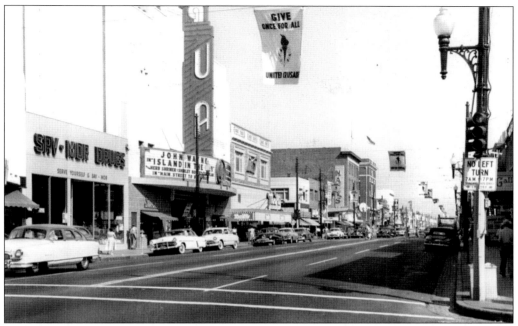

MACDONALD AVENUE AT EIGHTH STREET, 1953. In order to appreciate the changes that took place along Macdonald Avenue in the decades following World War II, take a look at this photo, looking east and showing a busy, vibrant downtown. Notice that the old Fox Theater is now the UA, and would soon become the Woolworth Building.

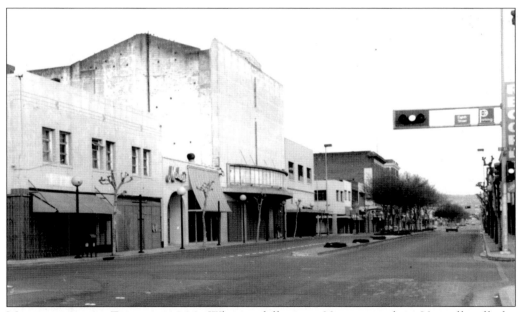

MACDONALD AT EIGHTH, 1986. What a difference 33 years makes. Virtually all the buildings between Eighth and Ninth Streets are now shuttered and empty. The area is brightened only a little by the trees planted down the median. This area is today filled in by the Kaiser Hospital parking garage.

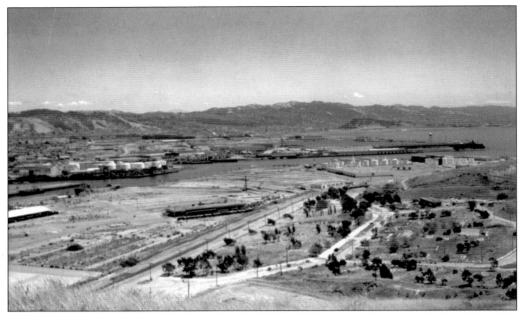

INNER HARBOR, EARLY 1960S. While the downtown was still humming at this date, the waterfront had taken on a desolate look. Shipyard #4 is gone, and so too are the Terrace Apartments to the right of Canal Boulevard. In the distance the Ford Building, now empty, can be made out.

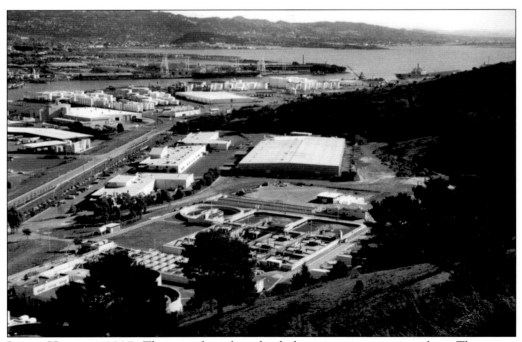

INNER HARBOR, 1997. The waterfront has clearly become a more active place. The empty areas are filled in and in the distance can be seen the cranes of the modern containerized port facility, which began operations in the late 1970s.

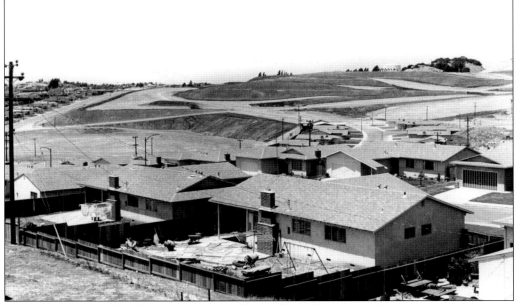

DEVELOPMENT IN EL SOBRANTE, C. 1960. Richmond continued to annex areas in the county, particularly in El Sobrante, in order to encourage development. This scene looks up Valley View Road. The flat area in the left center would become a little strip mall, anchored by a small Lucky Store.

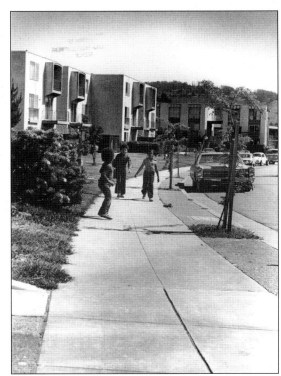

CRESCENT PARK, 1970. This housing development was and is located along Carlson Boulevard near Eastshore Park, in the same area that Richard Stege once had his frog ponds.

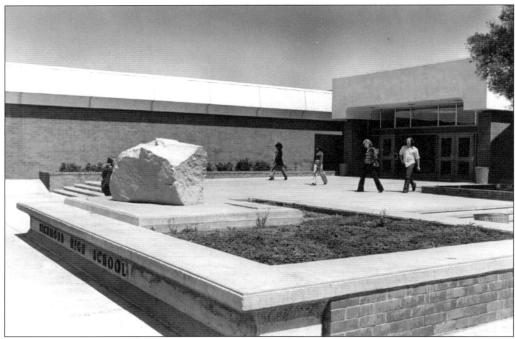

RICHMOND HIGH SCHOOL, C. 1970. The old high school, which had served since 1928, was torn down in 1968. This new structure was built in the same location. All that remains of the old school is the giant granite stone, a gift from the graduating class of 1935.

DOWNTOWN RICHMOND, EARLY 1970s. Some redevelopment has already taken place along Macdonald, as is evident by the trees planted along the median. This picture was taken at about Ninth Street and looks east. The Elks Building, just up the street, would later be torn down and the site would eventually become a community garden.

WINTERS BUILDING, 1979. Artist Tom Browne is placing the last piece of the "Ellis Landing" sculpture as part of the restoration of this historic structure, located between Harbour Way and Eleventh Street.

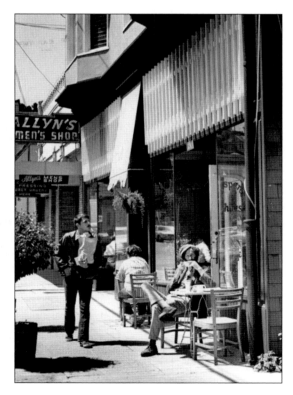

POINT RICHMOND, C. 1970. Coffee shops and conversation have always thrived in this corner of old Richmond. Its unique identity has been enhanced by the conservation of its entire downtown area, which is now on the National Register of Historic Places.

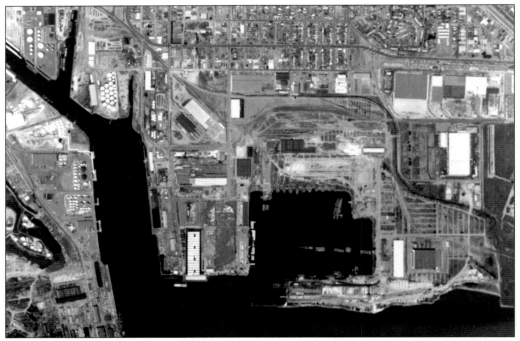

RICHMOND'S PORT, 1974. This aerial view of Richmond's southern waterfront was taken just prior to major redevelopment work, which would transform the shoreline. The area to receive the most dramatic alteration is the old Shipyard #2, in the lower center of this photo.

DEDICATING THE NEW PORT. Redevelopment of the port, to make the old Terminal #3 into a modern containerized operation, began in the late 1970s. In the center is Mayor Corcoran and on the left is Nat Bates, who has long served on the City Council. At the right is George Livingston, Richmond's first elected black mayor.

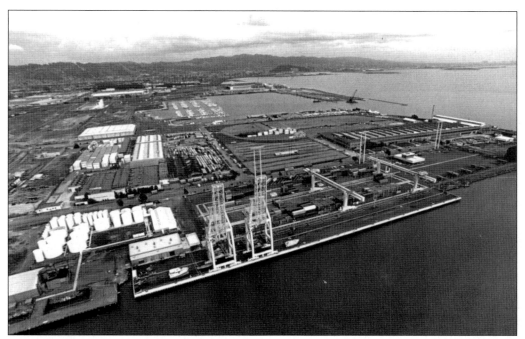

RICHMOND'S PORT, EARLY 1980s. In the foreground can be seen the new cranes of the newly constructed containerized port facility. In the distance can be seen Richmond's new marina, where Shipyard #2 used to be.

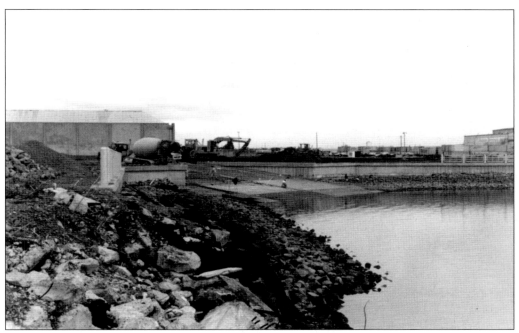

BUILDING THE LAUNCH RAMP, FEBRUARY 1981. Once begun, work proceeded quickly on the new marina. In the background can be seen some old structures which served the yard during the war. They would soon be torn down to make way for housing.

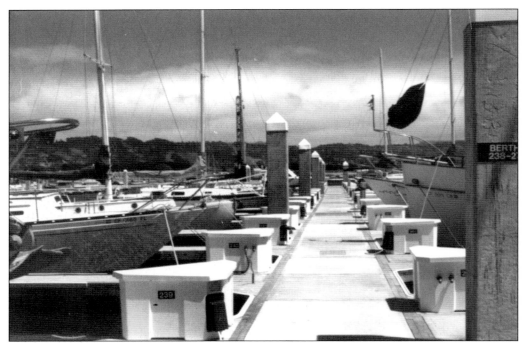

RICHMOND MARINA, AUGUST 1981. Though not officially opened till September 1981, many boaters had already taken up residence in the new slips, as can be seen from this photo.

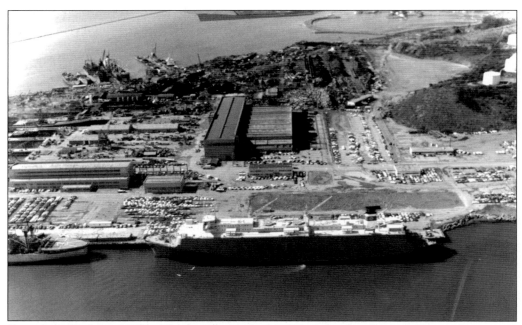

SHIPYARD #3, MID-1970S. This aerial view looks west across the shipyard. Just at the top can be seen the breakwater being built for the new Brickyard Cove Marina. Here too, in an area once dominated by industrial usage, the city now saw its future in the encouragement of residential and recreational development.

KELLER PARK, 1970. Richmond's Redevelopment Agency made many improvements to this popular beach area just past the tunnel at Point Richmond. In the distance can be seen the filled-in area that was once Santa Fe Lagoon, and would later become Miller-Knox Park.

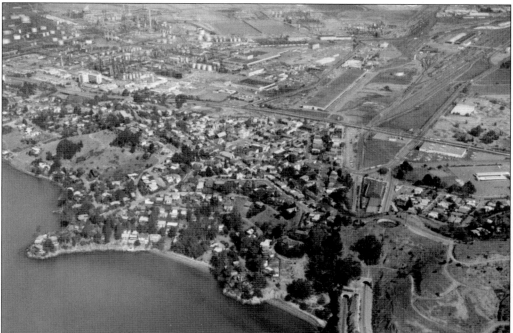

POINT RICHMOND, LOOKING NORTH, 1977. Keller Beach can be seen just to the left of the railroad tunnel. To the left of Keller Beach is the old Kozy Kove, now in private hands and no longer an amusement center.

RICHMOND BART STATION. This picture was taken just prior to the opening of the Richmond Bart Station in the late 1960s. The young lady is demonstrating use of the ticket machine. Behind her is a piece of fiberglass artwork by William Mitchell, depicting a marine theme.

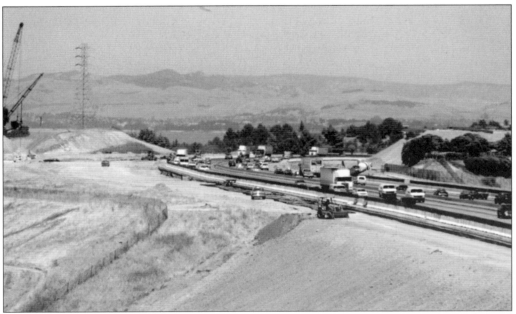

RICHMOND PARKWAY OVERPASS, HIGHWAY 80, 1995. The completion of the Richmond Parkway has opened a new chapter in Richmond's growth, encouraging business, park, and residential construction along its relatively undeveloped western and northern shorelines.

Eight
EPILOGUE
BACK TO THE FUTURE

As Richmond nears its 100th birthday, it has begun to look to its past for a sense of its identity and as a guide to its future. Not only in Richmond, but all over the country, there is a growing sense of urgency regarding the stories that are being lost every day, as the veterans of our nation's conflicts pass out of our reach. There is a growing resistance too, to the careless destruction of places and things that link us to our past and tie us to the deeds of our forefathers and foremothers. People may die, but the things that they created can be saved, and thereby serve to honor their existence and to give to us, the living, the sense that we are not adrift but on a road that has been someplace and is going somewhere.

Richmond now is home to nine sites on the National Register of Historic Places, and is in the process of adding more. Most of these sites are on or near the water, reinforcing the notion that Richmond is a town that has always looked to its waterfront to find itself. Nowhere is this more evident than on the town's southern shore, the old shipyard area, which encompasses three of the Register sites. The Rosie the Riveter World War II Home Front National Historical Park, dedicated to the preservation and display of Richmond's World War II heritage, is currently being developed in the same area. It is also along the south shore, the Marina Bay area, that the Rosie the Riveter Memorial is located. Along the city's western shoreline, where the Navy has vacated its fuel depot at Point Molate, there is even more history to preserve and to protect. There the old castle-like winery of Winehaven still sits amid the encircling eucalyptus trees, waiting to become again the recreational destination that it was almost one-hundred years ago.

Richmond contains many places that are historically meaningful, too many to be saved. But that only means that the places that remain are all the more precious. In this final chapter, we will look at some of the sites that have been saved and how they look today. Perhaps by recognizing what we have chosen to value, and to save, we can glimpse Richmond's destiny. That destiny seems to be not unlike the dreams of the town's early founders, who imagined a dynamic port city rivaling any on the Pacific Coast. But while heavy industry and commerce may not be as important as they once were, few doubt that Richmond's future does not depend upon a thoughtful and loving development of its magnificent shoreline.

WINEHAVEN TODAY. The old brick castle, at Point Molate, looks much as it did in 1907 when it was built. There is a legend that the eucalyptus trees that now surround the site were given as seed pods to a tour guide by Juanita Miller, daughter of visiting poet, Joaquin Miller. (Photo by author.)

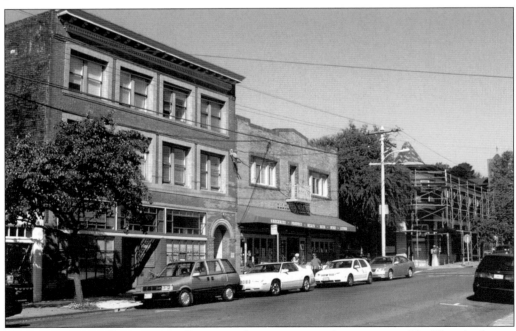

HISTORIC POINT RICHMOND. Compare this picture to that on page 32. The Anderson Building still proudly stands, as does the Bank of Richmond building. Not visible, but just up Washington Avenue from the bank, is the old Nicholl Building, Richmond's second city hall. (Photo by author.)

ALVARADO PARK TODAY. This lovely little park, through which Wildcat Creek flows, is enjoying something of a rebirth of interest, after being almost forgotten. The charming stonework is an excellent example of the kind of project authorized under President Roosevelt's WPA, during the 1930s. (Photo by author.)

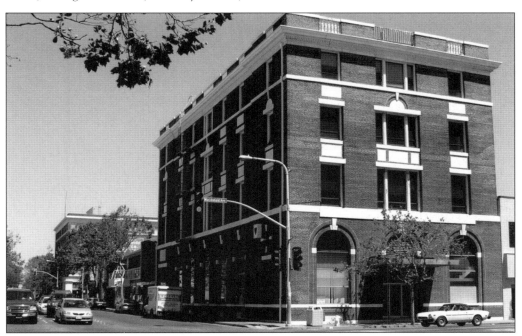

HARBOUR WAY AND MACDONALD. This view looks north on Harbour Way and shows the old American Trust (Wells Fargo) Building as it looks today. Further up the street is the Hotel Carquinez, now on the National Register. Compare this photo to that on page 72. (Photo by author.)

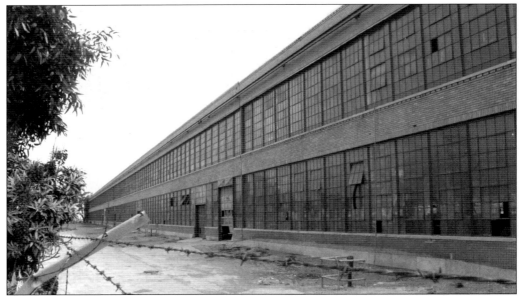

THE FORD BUILDING TODAY. Though a long way from opening to the public, this structure, at the foot of Harbour Way, has already undergone extensive repair work. Almost all the glass has been replaced. Though plans for its ultimate use are still being worked out, it promises to be a major draw for tourists and business people alike. (Photo by author.)

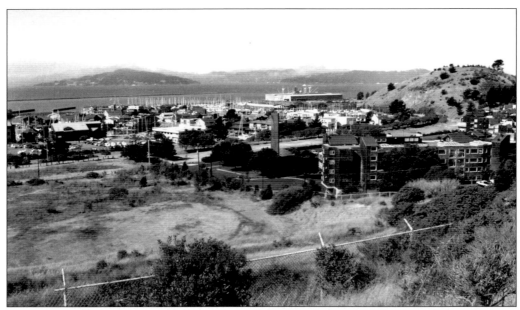

BRICKYARD COVE TODAY. In the center of this photo you can see one of the old brick smokestacks and a part of one of the kilns that operated here for so many years and gave this place its name. The stack and two domed kilns have been thoughtfully incorporated into the grounds of the condominium development. Just above and to the right of the stack is Terminal #1, behind which can be seen the spars of the *Red Oak Victory*. Compare this photo with that on page 53. (Photo by author.)

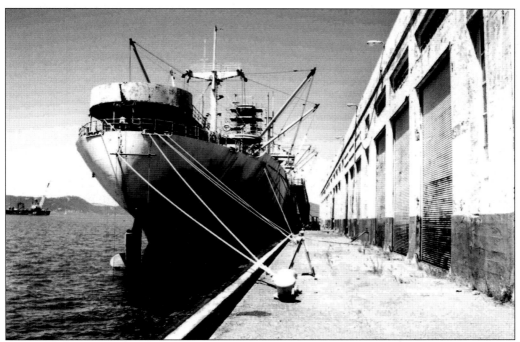

RED OAK VICTORY. Currently undergoing repairs and restoration, the *Red Oak* is currently moored alongside the wharf at Terminal #1, near Ferry Point. On the National Register, she is open to the public and is owned by the Richmond Museum Association. (Photo by author.)

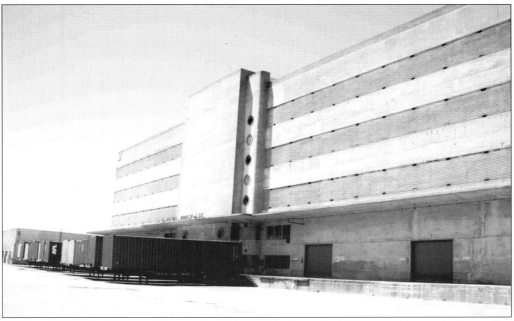

GENERAL WAREHOUSE, SHIPYARD #3. Also on the National Register, Shipyard #3 is still a working facility and not yet open to the public. However, plans are being laid to allow public access, particularly along a section of the Richmond Bay Trail. (Photo by author.)

ATCHISON VILLAGE. This World War II housing project is Richmond's newest addition to the National Register, attaining that position in May 2003. Atchison Village was one of just three war-time housing projects that were meant to be permanent. The others were Nystrom Village and Triangle Court. (Photo by author.)

ROSIE THE RIVETER MEMORIAL, MARINA BAY. We end with a look at this modest but affecting sculpture, dedicated in 1998 to the memory of the women who worked in the Kaiser yards in Richmond during the Second World War. Lying just to the east of the marina (old Shipyard #2), it reminds us once again of the leadership role that Richmond shouldered over 60 years ago, and which has shaped its destiny ever since. (Photo by author.)

by Shelley Evans-Marshall

SCHOOL PUBLISHERS

Orlando Austin New York San Diego Toronto London

Visit *The Learning Site!*
www.harcourtschool.com

Introduction

Animals live in many different types of places. The place an animal lives is called its habitat.

Forests

Black bears live in the forest. They have strong claws to catch fish and grab pinecones and berries.

In the trees, you might see squirrels, woodpeckers, and owls. Near the water, you might see otters and beavers. On the ground, you might see raccoons, snakes, and deer.

black bear

Rain Forests

Another type of forest is called a rain forest. Rain forests grow where the weather is very warm all year and a lot of rain falls.

Spider monkeys live in rain forests. Sometimes they hang by their long tails. Sometimes they swing from tree to tree. Spider monkeys, like many animals that live in the trees, do not spend much time on the ground.

spider monkey

Wetlands

There are different kinds of wetlands. Some words that describe wetlands are bog, marsh, and swamp. Many different plants, birds, fish, and insects live in and around wetlands.

Ducks live in wetlands. They have webbed feet that are good for swimming. Ducks usually make their nests along the water's edge.

duck family

Oceans

Whales live in the ocean. They come above the water for air. Whales have blubber, or fat, to keep them warm when the ocean is cold. They also have wide tails that help them swim.

Seaweed grows in the shallow ocean. Seaweed provides food for many animals in the ocean.

whale coming up for air

The Arctic

In the Arctic, the winter is long and the summer is short. Plants grow only in the summer in some parts of the Arctic. Small trees grow in the south. Grasses grow in the north.

Wolves, moose, reindeer, and polar bears live in the Arctic. Walruses, seals, and whales live in Arctic waters.

polar bear

Deserts

In a desert, less than 10 inches of rain falls each year. The temperature can be very hot or very cold.

On the ground in a desert, you might see snakes and lizards. You can also find rabbits, foxes, and camels in some deserts. In the deserts of Australia, you can find kangaroos!

Not only cactus live in the desert. There are also trees and grasses. You may also see some beautiful flowers.

lizard

Loss of Habitat

Some plants and animals are in danger of disappearing because their habitats are disappearing. Habitats can be harmed in different ways. One way is that people build cities on the land. Some people work to protect habitats and the plants and animals that live there.

lost habitat